The Future of Public Space

Allison Ari
Michelle N
Jaron Lani
Rachel Mo
China Miéville
Christopher DeWolf
Ben Davis
Sarah Fecht
Lawrence Weiner

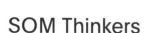

SOM Thinkers

Allison Arieff is the Editorial Director for SPUR.

Michelle Nijhuis writes for *National Geographic* and *High Country News*.

Jaron Lanier is a computer scientist, composer, visual artist, and author.

Rachel Monroe is a journalist, volunteer firefighter, and occasional radio host.

China Miéville is a weird fiction writer, academic, and activist.

Christopher DeWolf is the author of *Borrowed Spaces: Life Between the Cracks of Modern Hong Kong*.

Sarah Fecht runs the Earth Institute's *State of the Planet* blog.

Ben Davis is the national art critic for *artnet News*.

Lawrence Weiner is a language-based sculptor.

LAWRENCE WEINER

IN DIRECT LINE WITH ANOTHER & THE NEXT

New York City manhole cover, Public Art Fund and Con Edison,
New York, 2001

ART IS MADE TO BE USED

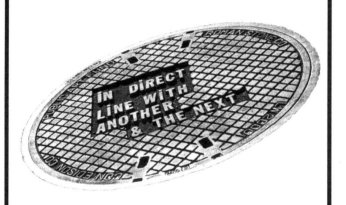

Introduction: Just Enough

Allison Arieff

"It's hard to design a space that will not attract people. What is remarkable is how often this has been accomplished."
–William "Holly" Whyte

There's a wonderful observation in the 1999 obituary of William Whyte: editor, urbanologist, observer. He was, writes Michael T. Kaufman, "in favor of razzmatazz, good honky-tonk, and anything that invested sidewalks with hustle and bustle."[1] This criteria! Public spaces, it suggests, are above all to be places of spontaneity and joy.

In 1980, when Whyte published his seminal work, *The Social Life of Small Urban Spaces*, we weren't yet tasked with conceiving of how the virtual public square might manifest (as Jaron Lanier discusses here), let alone imagining the future of public space on Mars. Public spaces were often created by fiat–not through the arduous process of community engagement. The more we learn, in fact, about how public space was created in the past, the more we find ourselves in the middle of vexing dilemmas: What does public space look like for everyone? What policies, practices, and physical artifacts exclude the public? Which ones are inclusive (and how can we have more of them)? Public space has become even more valued, but also far more complicated to create. The reasons for this are myriad and complex and form the raison d'être for this volume.

Spontaneity and joy are hard to achieve at the end of a grueling multi-year process of community engagement, environmental review, and fundraising. Our current moment reveals the extent to which we need to examine process as much as finished product. It also reveals that designing a space to attract people is an act in need of constant reinvention.

Though perhaps what needs reinvention is the impulse to constantly reinvent. Take one of my favorite public spaces, Alemany Farmer's Market in San Francisco. It is one of the very few places in this increasingly stratified city that attracts a truly diverse population. Founded in 1943 by a group of victory gardeners (the market moved to this location in 1947), it is the oldest farmer's market in the city. It is also the only one run by the city's government, and perhaps because of that it's also the least precious. At a time where most local businesses are closing or assuming new identities to serve San Francisco's increasingly young and affluent populace, Alemany shows no interest in changing the way it's been doing things since its first day of business.

Held in a massive–and largely unused–parking lot, Alemany, it must be said, is not much to look at. The vendor booths are concrete. Signage is cheerful but limited to faded murals of fruits and vegetables; public programming, such as it is, is a balloon lady and a guy playing the steel drums. Little thought was ever given to the flow of traffic or the path of pedestrians. Cars vying for parking idle right next to food trucks.

I'm always struck by how radically undesigned this place is. If there were meetings to figure out how to attract more people, those meetings had no outcomes other than to leave things as they were. Alemany feels very do-it-yourself, much like a project built from the ground up. Its plainness is what attracts–there's *just enough* to make it work. Were the city to undertake significant upgrades, it seems likely the market would lose much of its appeal.

Alemany embodies what Christopher de Wolf celebrates in his discussion herein of beloved Hong Kong markets in "Sensory Navigation in Hong Kong"–"the palimpsest of human activity." But Hong

Kong, he cautions, "is a place particularly vulnerable to late-capitalist development that privileges visual order and threatens sensory heritage, where … new development seems to have no tolerance for the mismatch of uses that has always characterized Hong Kong." That mismatch of uses, that human activity, is so often what draws us to many beloved public spaces—until it doesn't.

About a mile north of Alemany in San Francisco's Mission District is the 16th and Mission BART station plaza. Much of the human activity here is of the sort Jane Jacobs would have celebrated as "an intricate ballet in which the individual dancers and ensembles all have distinctive parts which miraculously reinforce each other and compose an orderly whole." Thousands use this BART station daily. There is a smattering of retail: a Walgreen's, a Burger King, a bank, some offices, a Chinese restaurant. Flowers, toys, and cellphones are sold off of fold-up tables; popsicles, cut fruit, and tamales are often sold off of wheeled carts. It's not unusual to see musicians performing on the corner. Pigeons perched on power lines survey the scene.

But there is a lot of drug activity here too. And trash on the ground. It's not uncommon to see knife fights, or discarded needles. There's a large homeless population, and not unrelated, one of the city's several attendant-monitored public bathrooms. Signs are posted that ask passersby not to use the wall as a restroom. Several social services and affordable housing opportunities for the poor and working class are located in the surrounding area, including forty-three SROs (single residence hotels).

Some community organizers refer to this space as an "open air living room"; others describe it as a place of danger and blight. Both views are correct,

but can they co-exist? So far they do, albeit tenuously. In 2016, the San Francisco Planning Department met over the course of nine months with community groups and activists in the neighborhood to develop a community design plan for the 16th and Mission station area. The planners were wholly unprepared for the outcome: the neighborhood refused all suggestions. No clean up, no trees, nothing. Why?

This once largely Latino neighborhood has become a flash point for issues around gentrification, displacement, and anti-tech sentiment. So controversy was not entirely unexpected when a developer called (I kid not) Maximus proposed a ten-story, 380-unit, mixed-use, transit-oriented development for the site, with twenty-four percent of units set aside for affordable housing. Neighborhood activists have been fighting ever since to stop the project, claiming it would cast shadows on the nearby elementary school and exacerbate gentrification. Referring to the project as the "Monster in the Mission," they have demanded that Maximus deliver a building made up entirely of affordable housing units—or nothing. Keeping the area as is—no new benches, no plantings, no cleaning—the thinking goes, will prevent further displacement.

It once seemed obvious, easy even: add public space, improve quality of life. But it's not so simple any more. Public space has busted out of its narrow definition and increasingly become something that needs to be controlled, policed, privatized, prevented even. It exists in the cloud and on social media, manifesting into what Jaron Lanier, in his essay "Why is the City Square Square?," calls "antigoras"—"the places where commoners gather online, acting as if they were first class citizens, still effectively innocent of the fact that they are under

intense surveillance and subject to stealthy behavior modification by algorithms."

In 2011, the Arab Spring came to be known as the Twitter uprising, but as it played out on the streets, the limitations and dangers of the virtual public square came to light. As Lanier explains, "those who stroll through the antigora submit to surveillance, scrutiny, and manipulation; more lab rats than freedom fighters." Twitter and Facebook were used as tools for organizing, but then became a means to root out oppositional voices. Lanier struggles with this contradiction and tries to figure out what a two-way internet might look like, how we might have a center, a city square, rather than the digital equivalent of sprawl.

Rachel Monroe picks up on this specter of big data in "Eyes in the Sky: Being Watched in the Rural West," where she makes the surprising assertion that we can best discover the future of surveillance in the rural Southwest. No hick towns here, observes Monroe, writing from West Texas: rural border surveillance takes advantage of cutting-edge technologies—as well as crowd-sourcing and gamification—and follows an established path "from the battlefield to the border to the city." Our cherished notions of the limitless-ness of the West and the freedom it offers are a touch out of date, she writes. "In today's technological landscape, these spaces provide the best sightlines: when there are so few people around, it's easier to zoom in."

Monroe brings up another disconnect: the point that nearly all of our debates about the use of public space presume an urban context and center on a city's plazas and parks. This is an area ripe for further exploration. Examinations into non-urban public spaces—suburban playgrounds, hiking trails,

and the like—might begin to reveal their own tensions and conflicts.

One of those examinations lies here with Michelle Nijhuis' exploration of how climate change is having an impact on our national parks, describing how the park service must now manage for "continuous change that is not fully understood." How do we plan for that exactly? By experimenting for starters, but also by being open to change. Nijhuis quotes Liz Davis, the chief of education for Assateague Island National Seashore, a national park site that is gradually shuffling west: "People ask, 'Will I still be able to enjoy it? Will my kids and grandkids be able to enjoy it?' The answer is yes, they will. They might not enjoy it in the same way, and they might not get here the same way. But they still will be able to enjoy it."

They may have to pay more for it though. In 2017, the proposed National Park Service budget was slashed by almost $400 million. To address that shortfall, the current administration has said it will turn to privatizing public park services—a move that would surely increase costs for visitors and put the egalitarian nature of visiting a park out of reach for some.

To zoom out further, consider outer space. In "The Public in Outer Space," Sarah Fecht careens past current preoccupations to how humans might survive space journeys, fast-forwarding to a time when we will need to figure out how to inhabit this new terrain. Public spaces, Fecht argues, may be even more important in space than here on Earth, essential to sanity and well-being thanks to "the hostile outdoor environment, cramped quarters, and the fact that everyone's life depends on everyone else." But who owns space? Really all of outer space is a public space, because according to the 1967 Outer Space Treaty, it belongs to all of humankind. But as

tech giants hurdle over one another to colonize the territory first, will the tenets of that treaty hold? Will the final frontier belong to the people or the conglomerate with the best rockets?

Back on Earth, privatization has emerged as one of the more vexing issues around public space. Generations of urban theorists have argued that how cities are made (and remade) is in the public rather than private sphere. When private interests manage or control those spaces, the freedom to do so is restrained. Some uses, populations and behaviors are sanctioned, others curtailed. We've seen an increase in the use of so-called defensive architecture: elements in public spaces, like spikes, speakers playing loud music or even jets of water, deployed to deter people from lingering, sleeping or sitting. How far will entities go to mandate how our spaces are used? To read China Miéville's fictional tale "Final Report" is to see just how far.

Public space is changing. From gentrification to grassroots activism, surveillance to privatization, we're only just beginning to grasp its increasing complexity. We now have an increasing awareness of the unintended consequences of once seemingly benign bike lanes, parklets, and plazas, and increasing resistance to many of the interventions that have become go-to tools in the urbanist toolkit. That has been a jarring experience for many, myself included. But I think it proves instructive. Hopefully this will encourage us to explore the issues of inequality, inequity, and environmental injustice that are emerging as a major part of the discourse around landscape architecture and city planning.

The "just enough green" model is attempting to address just this. It's a model that has emerged in response to a frustrating contradiction: low-income

communities tend to disproportionately suffer from various kinds of environmental injustices; yet when improvements are made to conditions in these communities, they become attractive to new investment and more affluent populations. A brownfield site is cleaned, transit accessibility is improved, a new park opens–suddenly a "bad" neighborhood is ripe for gentrification.

The challenge, then, may be in determining how much improvement is "just enough." Jennifer Wolch, Dean of the UC Berkeley College of Environmental Design, suggests that planners intervene not on a grand scale, but through modest projects such as small parks and community gardens that may not cater to the broadest public, but rather serve the immediate needs of an existing community. It's not that bigger, more spectacular green projects (such as the High Line) don't have a place in the urban landscape, but if that is the chosen direction for development of public space, such projects should at least incorporate local input and protect local culture. Further, whether big or small, such efforts need to deploy tools and strategies designed to mitigate the effects of gentrification and displacement, working in tandem with the construction of more affordable housing, preservation of existing housing stock, and development of more creative financing strategies (like those that help provide first-time buyers with a down payment)–tools that perhaps might have helped temper the response to change at 16th and Mission.

Achieving "just enough green" can prove elusive, but there have been a handful of success stories. For example, in the Brooklyn neighborhood of Greenpoint, lifelong residents and newcomers alike rallied around an effort to remediate Newtown Creek, a heavily-polluted tributary of the East River

forming part of the boundary between Brooklyn and Queens. Creating an organization known as the Newtown Creek Alliance, this diverse coalition of neighbors has worked to transform the contaminated waterway, along with a nearby sewage treatment plant, into cleaner, greener, and more accessible public amenities.

Perhaps another way to find the "right" kind of public space is to not erase all that preceded it. Such was the case with the former Tempelhof Airport in Berlin, historically associated with the Nazi regime and the Second World War. The airport closed its operations permanently in 2008, but was subsequently re-opened as a public park, with an original plan that included nearly 5,000 new residences with high-end retail, designed by a group of internationally renowned architects. Berliners, fearing the socio-economic changes that often accompany such development projects, however, rejected this plan in a 2014 referendum and for now, it remains pretty undesigned–and extremely well-used.

So how do we think about creating public spaces that advance public health, equity, and social justice and are also places people want to spend time? If we tick every box do we create something so over-programmed that no one wants to go there? How do we avoid "the big sort" of public realm, where, just as people are increasingly self-selecting neighborhoods to surround themselves with people most like them, people similarly choose public spaces using that same criteria?

This squares with Ben Davis' observations in "The Future of Public Art in Five Phases." Aesthetics, he writes, "have been drafted into service to respond to various economic-political conflicts, yet also continuously found themselves at the mercy of economic

political shifts they cannot themselves control." Davis is writing about art but could just as well be describing the betterment efforts at 16th and Mission. How this all plays out is anyone's guess. Public art (and I'd argue, public space), at one extreme, he predicts, will "likely be a symbol of the city as luxury commodity. At the other, it will be testimony to inadequate and under-resourced government policy. Or society itself will become more equal"

In his series of images on public art showcased here, Lawrence Weiner reveals this written on a manhole cover: "In direct line with another and the next," in reference to the grid pattern of New York City's streets. Instead of a precious sculpture set on a pedestal, Weiner's work is walked on by tourists and residents of the city, all of whom have equal access to it. The work refers as well to the odd democracy of New York City. Though it's a city of vast extremes, the rich and poor, powerful and disenfranchised still all wait for the same "Don't Walk" signs to change when crossing the street. Standing in line, riding the subway, walking down the street, New Yorkers are always "in direct line with another and the next."

Our civic spaces and their accompanying regulations are a reflection of what—and who—we value. So let's take our cue from the optimism of Davis and Weiner in imagining their democratizing potential. That the essays in this volume take us everywhere from West Texas to Mars reveals the infinite variety—and possibility—of this space. There is not, nor will there ever will be, a formula for creating successful public spaces. The task of doing so is perhaps not so easy as Whyte once imagined, but if we add equality, equity, and environmental health to the equation of spontaneity and joy, we may be one step closer.

1 http://www.nytimes.com/1999/01/13/arts/william-h-whyte-
 organization-man-author-and-urbanologist-is-dead-at-81.html

LAWRENCE WEINER

SMASHED TO PIECES
(IN THE STILL OF THE NIGHT)

Wiener Festwochen, Flakturm, Esterhàzypark, Vienna, 1991
Photo: Christian Wachter

FOR ART TO BE USED IT MUST BE SEEN

How the Parks of Tomorrow Will Be Different

Michelle Nijhuis

Assateague Island National Seashore, which sits on a thirty-seven-mile-long sliver of land just off the coast of Maryland and Virginia, is gradually shuffling west. Over centuries, as hurricanes and nor'easters drive sand from its Atlantic beaches across the island and into its bayside marshes, the entire island is scooting closer to the coast.

"It's neat, isn't it?" says Ishmael Ennis, hunching against a stiff spring wind. "Evolution!" He grins at the beach before him. It's littered with tree stumps, gnarled branches, and chunks of peat the size of seat cushions—the remains of a marsh that once formed the western shore of the island. Later buried by storm-shifted sand, it's now resurfacing to the east, as the island shuffles on.

Ennis, who recently retired after thirty-four years as maintenance chief at Assateague, has seen his share of storms here. This national seashore, in fact, owes its existence to a nor'easter: In March 1962, when the legendary Ash Wednesday storm plowed into Assateague, it obliterated the nascent resort of Ocean Beach, destroying its road, its first thirty buildings, and its developers' dreams. (Street signs erected for nonexistent streets were left standing in a foot of seawater.) Taking advantage of that setback, conservationists persuaded Congress in 1965 to protect most of the island as part of the National Park System. Today it's the longest undeveloped stretch of barrier island on the mid-Atlantic coast, beloved for its shaggy feral ponies, its unobstructed stargazing, and its quiet ocean vistas—which have always been punctuated, as they are on other barrier islands, by impressive storms.

Scientists expect that as the climate changes, the storms will likely strengthen, sea levels will keep rising, and Assateague's slow westward migration

may accelerate. Ennis knows the island well enough to suspect that these changes are under way. Assateague's maintenance crew is already confronting the consequences. On the south end of the island, storms destroyed the parking lots six times in ten years. The visitors center was damaged three times. Repair was expensive, and after fist-size chunks of asphalt from old parking lots began to litter the beach, it began to seem worse than futile to Ennis.

A tinkerer by nature—he grew up on a small farm on Maryland's Eastern Shore—he realized the situation called for mechanical creativity. Working with the park's architect, Ennis and his co-workers adapted the toilets, showers, and beach shelters so that they could be moved quickly, ahead of an approaching storm. They experimented with different parking lot surfaces, finally arriving at a porous surface of loose clamshells—the kind often used on local driveways—that could be repaired easily and, when necessary, bulldozed to a new location. "It was a lot of what we called 'Eastern Shore engineering,'" Ennis says, laughing. "We weren't thinking about climate change. We did it because we had to." He lowers his voice, mock-conspiratorially. "It was *all by accident*."

Accidental or not, these modest adaptations were the beginning of something broader. The seashore is now one of the first national parks in the country to explicitly address—and accept—the effects of climate change. Under its draft general management plan, the park will not try to fight the inevitable: It will continue to move as the island moves, shifting its structures with the sands. If rising seas and worsening storm surges make it impractical to maintain the state-owned bridge that connects Assateague to the mainland, the plan says, park visitors will just have to take a ferry.

When Congress passed the act creating the National Park Service in the summer of 1916, it instructed the agency to leave park scenery and wildlife "unimpaired for the enjoyment of future generations." The law did not define "unimpaired." To Stephen Mather, the charismatic borax magnate who served as the first director of the Park Service, it meant simply "undeveloped." Early park managers followed his lead, striving both to protect and to promote sublime vistas.

But the arguments began almost as soon as the agency was born. In September 1916 the prominent California zoologist Joseph Grinnell, writing in the journal *Science*, suggested that the Park Service should protect not just scenery but also the "original balance in plant and animal life." Over the next few decades, wildlife biologists inside and outside the agency echoed Grinnell, calling for the parks to remain "unimpaired," in ecological terms. But the public came to the parks for spectacles—volcanoes, waterfalls, trees you can drive a car through—and preserving them remained the agency's primary concern.

In the early 1960s, Secretary of the Interior Stewart Udall—who would oversee the addition of nearly fifty sites to the National Park System, including Assateague—became concerned about the agency's management of wildlife in the parks. He recruited University of California wildlife biologist Starker Leopold, the son of famed conservationist Aldo Leopold, to chair an independent study.

The Leopold Report proved hugely influential. Like Grinnell, it called on the Park Service to maintain the original "biotic associations" that existed at the time of European settlement. In the decades that followed, the Park Service got more scientific. Park managers began setting controlled fires in forests

where natural wildfires had long been suppressed; they reintroduced species that had vanished, such as wolves and bighorn sheep. The focus, though, was less on restoring ecological processes than on re-creating static scenes—on making each park, as the Leopold Report recommended, into a "vignette of primitive America." In time that vision took on what Yellowstone historian Paul Schullery describes as an "almost scriptural aura."

And yet, as Leopold himself later acknowledged, it was misleading. The notion of presettlement America as primitive ignored the long impact Native Americans had had on park landscapes, through hunting and setting fires of their own. It ignored the fact that nature itself, left to its own devices, does not tend toward a steady state—landscapes and ecosystems are always being changed by storms or droughts or fires or floods, or even by the interactions of living things. The ecological scenes the Park Service strove to maintain, from a largely imagined past, were in a way just a new version of the spectacles it had always felt bound to deliver to visitors.

"The Park Service has had a tacit agreement with the American public that it's going to keep things looking as they've always looked," says Nate Stephenson, an ecologist who studies forests at Sequoia, Kings Canyon, and Yosemite National Parks. "But time does not stop here."

From the 1980s on, scientists gradually came to accept that a new sort of change was under way. The glaciers in Glacier National Park were shrinking, wildfires in Sequoia were getting larger, and coastal parks were losing ground to rising seas. Shortly after the turn of the century, researchers in Glacier announced that by 2030 even the park's largest glaciers would likely disappear.

In 2003 a group of researchers at the University of California, Berkeley began to retrace the footsteps of Joseph Grinnell. In Yosemite and other California parks, the zoologist had conducted fanatically detailed wildlife surveys, predicting their value would not "be realized until the lapse of many years, possibly a century." When the Berkeley researchers compared their own Yosemite surveys and other data with Grinnell's ninety-year-old snapshot, they noticed that the ranges of several small mammals had shifted significantly uphill, toward the ridgeline of the Sierra Nevada. Two other once common mammals, a chipmunk and a wood rat, were almost extinct in the park. The pattern was clear: Climate change had arrived in Yosemite too, and animals were migrating to escape the heat.

For a while the Park Service avoided talking about the subject. To acknowledge the reality of human-caused climate change was a political act, and the Park Service doesn't discuss politics with its visitors. At Glacier the interpretive signs made only a passing reference to rising temperatures. Rangers avoided talk of causes. "We were very constrained," remembers William Tweed, former chief of interpretation at Sequoia and Kings Canyon. "The message we got from above was basically, 'Don't go into it if you can help it.'"

The problem, though, ran deeper than transient politics. People had long come to national parks to experience the eternal—to get a glimpse, however deceptive, of nature in its stable, "unimpaired" state. The inconvenient truth of climate change made it more and more difficult for the Park Service to offer that illusion. But no one knew what the national parks should offer instead.

When Nate Stephenson was six years old, his parents fitted him with boots and a hand-built

wooden pack frame and took him backpacking in Kings Canyon National Park. For most of the fifty-three years since, Stephenson has been hiking the ancient forests of the Sierra Nevada. "They're the center of my universe," he says. Soon after he graduated from UC Irvine, he packed up his Dodge Dart and fled Southern California for a summer job at Sequoia National Park. Now he's a research ecologist there, studying how the park's forests are changing.

While park managers are often consumed by immediate crises, researchers like Stephenson have the flexibility—and the responsibility—to contemplate the more distant future. In the 1990s this long view became deeply disturbing to him. He had always assumed that the sequoia and foxtail pine stands surrounding him would last far longer than he would, but when he considered the possible effects of rising temperatures and extended drought, he wasn't so sure—he could see the "vignette of primitive America" dissolving into an inaccessible past. The realization threw him into a funk that lasted years.

"I was a firm believer in the mission of the Park Service," Stephenson remembers, "and suddenly I saw that the mission we had was not going to be the same as the mission of the future. We could no longer use the past as a target for restoration—we were entering an era where that was not only impossible, but might even be undesirable."

Stephenson began what he calls a "road show," giving presentations to Park Service colleagues about the need for a new mission. Somewhat mischievously, he proposed a thought experiment: What if Sequoia National Park became too hot and dry for its eponymous trees? Should park managers, who are supposed to leave wild nature alone, irrigate sequoias to save them? Should they start planting

sequoia seedlings in cooler, wetter climes, even outside park boundaries? Should they do both—or neither?

His audiences squirmed. Leopold had left them no answers.

On a late September day in Sequoia National Park, the sky is clear, blue, and thanks to a brisk wind, free of smoke from the wildfire burning just over the crest of the Sierra Nevada. Stephenson and his field crew are finishing a season of forest surveys, adding to a decades-long record of forest health. In their lowest-elevation study sites, below the sequoia zone, sixteen percent of the trees have died this year, approximately ten-fold the usual rate. "It's about what you'd see after a low-grade wildfire," says Stephenson. Weakened by years of drought, many of the low-elevation trees are dying from insect attacks. At higher elevations, in the sequoia stands, several old giants have dropped some of their needles to combat drought stress; a few that were already damaged by fire have died. "It's not 'The sequoias are dying,' " Stephenson emphasizes. "The sequoias are doing relatively well. It's the pines, the firs, the incense cedars—the whole forest is affected."

The current drought may be a preview of the future, but the trouble with climate change—at Sequoia and elsewhere—is that many of its effects are hard to predict. Average temperatures at Sequoia will rise, and snow will give way to rain, but it's not clear whether total precipitation will increase or decrease, or whether the changes will be gradual or abrupt. "We don't know which scenario is going to play out," says Sequoia and Kings Canyon Superintendent Woody Smeck. The Park Service can no longer recreate the past, and it can't count on the future. Instead, it must prepare for multiple, wildly different futures.

In 2009 Park Service Director Jonathan Jarvis assembled a committee of outside experts to reexamine the Leopold Report. The resulting document, "Revisiting Leopold," proposed a new set of goals for the agency. Instead of primitive vignettes, the Park Service would manage for "continuous change that is not yet fully understood." Instead of "ecologic scenes," it would strive to preserve "ecological integrity and cultural and historical authenticity." Instead of static vistas, visitors would get "transformative experiences." Perhaps most important, parks would "form the core of a national conservation land- and seascape." They'd be managed not as islands but as part of a network of protected lands.

The report is not yet official policy. But it's the agency's clearest acknowledgment yet of the changes afoot and the need to manage for them. Exactly what that management looks like isn't certain, and much of it will be worked out park by park, determined by science, politics, and money. Some parks have already gone to great lengths to resist change: Cape Hatteras National Seashore, for instance, spent almost $12 million to move a famous lighthouse a half mile inland. But such dramatic measures are rare and likely to remain so; the Park Service budget today is about what it was in 2008.

Instead, many parks are looking to boost their tolerance for change, adapting their own infrastructure and helping their flora and fauna do the same. At Indiana Dunes National Lakeshore, scientists are searching the oak savannas for cooler microclimates into which the Park Service might transport the endangered Karner blue butterfly, which has been all but driven from the park. In Glacier, biologists have already captured bull trout and carried them in backpacks to a higher, cooler lake outside their historic

range. The idea is to give the fish a refuge both from climate change and from invasive lake trout.

At Sequoia, Stephenson wants park managers to consider planting sequoia seedlings in a higher, cooler part of the park–to see how the seedlings fare, and also how the public would respond to experimenting with the icons. "We have to start trying things," he says.

At Assateague, while Ennis's successors prepare the parking lots and toilets for change, Liz Davis, the chief of education, is preparing the park's younger visitors. In twenty-five years at Assateague she has introduced countless school groups to the seashore. When elementary students visit, she takes them to the beach, shapes a model of the island out of sand, and throws a bucket of seawater across it to show how the island shifts. Then she turns the model over to the kids: Where would they put the parking lots and campgrounds? How about the visitors' center? "They get really into it," she says, laughing. "They'll say, No, no, don't put the new ranger station there, it'll get washed away!"

Like the Park Service, visitors must learn to accept that their favorite park might change. "People ask, 'Will I still be able to enjoy it? Will my kids and grandkids be able to enjoy it?'" Davis says. "The answer is yes, they will. They might not enjoy it in the same way, and they might not get here the same way. But they will still be able to enjoy it."

LAWRENCE WEINER

(PUT) ON A FIXED POINT

———————————————————

(TAKEN) FROM A FIXED POINT

City of Calais, Lighthouse, 1992
Collection of Fonds National d'Art Contemporain, Puteaux, France

IN ORDER TO BE SEEN ART MUST BE PUBLIC

Why is the City Square Square?

Jaron Lanier

The digital layer of civilization is the first one that is entirely our responsibility. No circumstances or constraints were imposed on us. We could have made it anything, limited only by the hard stop of mathematics and engineering possibility.

Soon, however, it will be the fault of the ancestors. Freedom is more fleeting in the digital domain than in physicality. Bulldozers can trample an ancient city and impose the designs of a careless new empire. It's so commonplace as to be expected.

But foundational digital designs, and the political might and wealth associated with them, can get "locked in." For instance, there can be many new apps, but rarely will there be a new app store.

Some cities can choose their locations, and those are the ones that can die. But some are compelled. Istanbul is compulsory.

Digital designs are their own geography. They can create their own inevitability. There are many reasons why, which I won't go into here. Lock-in is a subtle but powerful fact of digital life. It is also quickly becoming the core fact of modern economics, politics, and culture.

Long ago, engineers chose a few principles of digital design that practically–but not quite–lock our descendants into a certain kind of digital public square. Call it an "antigora," an agora in reverse. (It is only one example of what I call a "siren server" in my book *Who Owns the Future?*)

Digital fate is not absolute, but people will have to work hard to change their fate, if that is to be their choice.

There is a startling disconnect between the rhetoric of the online world and reality. The clichés are so prevalent that only a few worlds are needed to trigger

the whole plodding narrative of our age. Try it: "The Internet is the new Gutenberg, opening up communication so that anyone can ..." Go ahead, finish it.

And yet, how many individuals have a personal web page? In truth, almost everyone who has a presence online has chosen to do so via a contract with a big corporation like Facebook. Similarly, almost anyone who distributes a program online does it through a big corporation like Apple.

These corporate squares are the anointed antigoras. They are the places where commoners gather online, acting as if they were first class citizens, still effectively innocent of the fact that they are under intense surveillance and subject to stealthy behavior modification by algorithms. This is true even though by now, post-Snowden, everyone knows; a sickly coating of consent must be present, though we are loath to admit it.

An antigora is an Orwellian architecture, though it might no longer be possible to say so and be understood. Vocabulary is turned upside down in an antigora. "Social media" means choosing to express oneself through a big corporation. "Decentralized" means you really have no choice but to sign up, and that the corporation will know more about you than you know about them. "Viral!" and "Disruptive!" are cherished as the laudatory cheers of our times. The internet was not made for cats, apparently, but for infectious disease. It's useless to call our topsy-turvy tech language "Orwellian" because the surrounding rhetoric is all about free speech; Orwell is pwned.

An antigora *feels* like an agora but is actually more like what Skinner would do with a panopticon. An antigora is usually controlled by a corporation in California or China, or somewhere else with

governments peeking in. In this setting I describe the California version.

Those who enter are addressed as if they are conquering liberators. "Here is your zone of free speech. Share!" What actually happens is that those in the antigora are observed so well that an information asymmetry arises.

Those who stroll the antigora submit to surveillance, scrutiny, and manipulation; more lab rats than freedom fighters. Speech gets freer and freer as it matters less and less. Every tweet of complaint about anything feeds the giant algorithms that calculate ways to increase wealth and power divisions. Free speech transforms into an opiate for the masses.

The internet is not a giant open space where equals meet. It's a place where symbols of equality serve the concentration of power and wealth. The owners of an antigora don't send in tanks to flatten the lumpen, but still fatefully gain an information advantage that tilts events in their own favor, even though it is from an arms-length, almost inert position.

The method is perfectly and precisely boring. Gradually, those who have entered the antigora come under the influence of algorithms. There is no brute force, but instead the micromanagement of choices presented.

A constant stream of suggested behaviors are placed in front of people, and on a gradual, statistical basis, the crowd acquiesces. It is not possible to look at a million options, so the recommended ones become the only ones. The vastness of the internet becomes its narrowness.

Sex partners are specified, but more to the point, products are sold, loans are made, votes are cast, attention is directed. Giant financial meltdowns (mortgage backed derivatives, automated

trading) occur on autopilot, no one at fault, the public holding the tab. Wages don't rise because algorithms figure out how to manipulate people into freelance arrangements where they are on call and unable to plan a career. There are many flavors of systemic information asymmetry, but at heart they are all similar.

Token numbers of commoners in the antigora are thrown bones, like a way to make a respectable amount of money by self-publishing a romance novel, driving people around, or posting a funny video. This spurs mad dreams in the rest.

A slight—but cumulative and compounding— imbalance turns into a gigantic gap in wealth and influence. Off to the side, those who spy quickly become ultra-billionaires and dream of immortality. A few of the kinder ones float ideas for keeping the masses from starving once the robots get good. A basic income model? Humanity as a kept species.

Why was the ancient city square square? In China, as in Europe, as in Mesoamerica? Because bald geo-metric symmetry is the opposite of chaos.

This is an admittedly retro way of thinking. Fashionable or not, it's a perspective we must keep in mind during digital times.

Briefly: Before cities, we roamed. We hunted and gathered. Our small bands slithered in terror through contested terrain not of our own design. Later, our tribes wandered, looking for signs.

The only environment we knew was fractal and organic, dotted with secret caves and springs, staged by the seasons, veined with hope and doom.

Then we learned to change our world (agricul-ture) and came upon a revolutionary choice: We sometimes might stay to work a place, to improve it.

But there were always competing bands of people. Our world was still contested. So, we defended our places. We built forts and castles. Then, castles big enough to outlast a siege. Cities.

Cities turned our world upside down. Before, we had found strength in speed and agility. Now, we found strength in numbers.

No phalanx was too broad, no area of cultivation was too vast, and no city walls were too high. Cities were strength. Each one an island empire until it was eventually breeched and bled into submission to a larger empire.

At the center of the city was a repudiation of the surrounding chaos. Geometry ruled. That is why the square is square. (If not a square then occasionally some geometric cousin; a triangle or a circle.)

The reason this creation tale for a shape is worth telling is that it illuminates the underbelly of our liberal imaginations.

It's not uncommon, today, to use the city square as a metaphor for democracy, but squares predate democracy. They signified power before they signified fairness. First came Athens for survival, then came the Athens of ideals.

Today, a plaza in a world city like Toronto, New York, or Los Angeles might, on a good day, be an open-air temple to the ideals of tolerant, fertile cultural mixing. You hear languages from all over the world at once, while watching children chase balloons. But at first, the square was a symbol of safety from aliens. Aliens would stoop to anything, like hiding in a big sculpture of a horse, to breech the geometry of separation and order.

The square originally meant submission in exchange for safety *before* it meant democracy. That ancient turnaround confuses us to this day. Hidden

in the heart of any practical or reliable form of freedom is a submission to an order that protects us enough to not be sacked by Trojans, not to mention highwaymen, predators, hackers, and grifters.

How can we reconcile ourselves to this intrinsic compromise? This has been a tension since the first city wall was raised and the first square laid out.

We are fickle. As soon as people taste life behind the city wall, they miss the open country, and vice versa.

In America, in the happy years after World War II, we laid out our civilization as an ever-expanding, centerless, ever-safe sprawl. Freeway, fast food, gas station, mall, and then a big chain store: endless, recombinant, always the same, never precisely so.

We chose to live in a fractal landscape, rather like the world of fairytale dangers we remembered beyond the old walls, except without the danger. Instead of springs and caves, franchises and freeways, repeating food, repeating shelter, strewn about in an almost rhythmic pattern, from horizon to horizon. We roam freely from drive thru to drive thru, but without worrying that we might be someone else's lunch.

American symbolism is all about not needing the city. We can't let go of the Old West, at least as we imagine it. To each a gun. We pretend to hate the government, even as we suckle up to it. This one sentence summarizes American politics.

In a structure-less world, we feel free. We don't feel ourselves positioned relative to power, even though we are, more than ever.

I grew up in the real Old West and watched it turn into the fake Old West. Mesilla, New Mexico, wasn't surrounded by walls, but happened to be a natural island in the Rio Grande, which used to be broad enough to have islands before it was dammed

into the tiny trickle it is today. Mesilla was naturally defensible. Spaniards laid it out around a square, naturally. To the north a church; to the east a jail. The church remains; the jail is now a gift shop.

When the territory passed to the United States, Mesilla faded. Las Cruces, an upstart town on higher ground also had a square, and then even a railroad stop and a main street. At the start of the 1970s it got a little mall, which seemed impossibly large to children. But the city wanted none of these things.

Las Cruces wanted the sprawl, and that's what's there today, even though there isn't much of it, because it's a small town. Anything that might have been perceived as a center has rotted. Civic energy courses only through the familiar, approximately repeating patterns of big chain store, fast food, chain hotel; ingredients tossed on a pizza. Even tiny cities can be centerless.

When the first architectural notions for digital networking were expressed by a Harvard student named Ted Nelson in 1960, he, and most other researchers of the period, imagined the digital world as a place like a city, meaning with a center. Why chart a center in a digital city?

The reasons were related to the original reasons cities came into being. I can only touch on the topic here, but briefly: in early notions of digital network architecture, like Nelson's, whenever anyone connected to anyone else, it would be noted. In other words, links went both ways. You couldn't just point to something, or copy something. Instead you'd always leave a calling card. The usual term in the trade is "two-way linking." If you link to someone or something, they are automatically linked to you. Break one link and you break the other.

There were many interesting implications of this
simple idea. One was that if people enjoyed or made
use of each other's efforts, a new kind of economy
could be created by sending micropayments between
them—not through an antigora, or a particular propri-
etary store—but through a universal societal system.
An agora!

This in turn is important because it's the only
real idea on the table I know of for how people could
earn money if the robots ever get good enough to put
everyone out of old-fashioned jobs. But the point is
that it would be a universal system. Everyone would
participate in it.

So it would have at least one kind of center.
There would be some sort of universal bank of the
internet. This would be more like a traditional city
square.

Over the next half-century, the original idea of
the two-way internet was gradually repudiated, so
that the internet we have today is based on one-way
links. What that means is that if you link to some-
thing, whoever maintains that thing doesn't know
you are doing so. If you copy something, there is no
record.

It's a digital world where context is iffy. Is that
a real picture? Where did that video really come
from? Who hacked those files? Are you a catfish?

Why did we choose the sprawl instead of the
center? This was a long, strange cultural odyssey.
In the 1960s and 1970s, angry young men afraid of
getting drafted longed for anonymity and a ghost-
like existence, like in the old Wild West. They killed
part of it.

I also remember people simply adoring the
romance of creating a new space we could treat
as a wilderness even though we made it. An

advocacy group was called "The Electronic Frontier Foundation." Fantasy places like Second Life tended to have a fractal, trackless quality to them. We seemed to almost celebrate the fact that acidic teenage boys with a little determination could derail corporations and armies for a moment now and then, or humiliate maidens, just like the highwaymen of the bad old spaces between cities.

Another issue was that celebrated "viral" quality. The World Wide Web had competitors when it launched, but it was the only contender that required only one-way links. One-way links spread with much less fuss, since you don't have to keep track of them. So the World Wide Web took off.

Up until then the internet was mostly theoretical; up for grabs. After, it was geography, more solid than California.

The architecture of sprawl turned out to be a setup for the quickest vast fortunes in history. A lot of what the biggest Internet companies do is recreate the back links.

If the internet had been born with two-way links, it would be easy to look up how many sites are looking at a site, so you could go to the site being looked at the most if you wanted to. But in a 'net with one-way links it's a *lot* of work to figure something like that out. Google has to read the *whole* web every night to calculate the back links that should be there anyway, just in order to come up with its search rank. Google's towering fortune was built on filling an artificial hole, which was left vacant only because of a peculiar sense of romance.

Similarly, if the 'net had two-way links, you'd be able to meet people who were interested in what you were up to, because the back link would be a calling card. Instead *that* hole has been filled by Facebook.

I'm exaggerating. There is more to running an internet company than restoring the back links, but that is the core of it.

By rejecting a center for the internet as a whole, we demanded that corporations create ersatz centers, the antigoras. When you reject the public center, you will instead get private centers, which are often camouflaged and tricky.

We miss the wilds. But they scare us. We hate the city, which jams us in with aliens. But we need it. So we fake the wilds in a city without an apparent center. We are drawn in by the feeling, but the actuality is that we become beholden to new centers that exploit us.

We have yet to settle into a comfortable shape.

LAWRENCE WEINER

BROUGHT TO LIGHT

University of California, San Francisco, 2010
Collection of University of California San Francisco
Photo: Mathieu Gregoire

ERGO: ALL ART WE KNOW IS PUBLIC

Eyes in the Sky: Being Watched in the Rural West

Rachel Monroe

On a Saturday night in Far West Texas, two men were talking in the bar. I could tell they were tourists by the way they talked about the sky. "I just feel more *free* here," said one of them. His eyes were shining. "It's so open, you can do anything."

The mythology of the wide-open West and the "anything" you can do there has been central to America's self-conception since the colonists first turned their backs on the Atlantic Ocean and confronted the wilderness in front of them, at once compelled and intimidated by the idea of all that land as an open frontier. In his essay "Walking," Henry David Thoreau admits to feeling the magnetic pull of the West: "The future lies that way to me, and the Earth seems more unexhausted and richer on that side." Tempted by the promise of untapped resources, the frontiersmen set out for the territories, displacing indigenous populations in their quest for presumed riches and a way of living free of bourgeois constraints. Seemingly unlimited space meant seemingly limitless options for fresh starts and self-invention. If things didn't work out as planned, there was always more West in front of them, more room for reinvention. Until, of course, there wasn't.

These days, only a few decades distant from the days of the unmapped "Wild West," you can view a remote patch of the Southwest desert via Google Earth, zooming in close enough to see the individual branches on a particular ocotillo. And yet, the idea of the West–particularly the Southwest–as freedom, as openness, persists: "Discover the freedom of the Southwest's open roads," the Lonely Planet's *USA Best Trips* guide promises. The sweeping vistas of the American West continue to inspire *this land is your land, this land is my land* feelings, and for good reason: in the eleven westernmost states, the

federal government owns nearly half of all the land, most of which is open for public use; only about four percent of the rest of the United States is designated as public land.

I myself was seduced by the Lonely Planet version of the West. Five years ago I drove across the country by myself in a Volvo sedan I was convinced would make it to 300,000 miles, pointed toward California and daydreaming of palm trees. I remember the afternoon I drove through West Texas, that evening's slow and gaudy show of a sunset, pink and gold smeared across the wide horizon. I could drive fast out here, and there were long stretches with no other cars on the road. Space. Freedom. I had never realized just how *watched* I felt in the cities of the East Coast, where I'd spent most of my life, how hemmed in by their pure human density. Something about being the only car on the long ribbon of road beneath that wide expanse of sky made me feel suddenly and distinctly *American*. And that Americanness was somehow tied to this public kind of privacy, the sense of being outside and alone and unwatched.

I scrapped California in favor of moving to Marfa, Texas. It took only a couple days in my new home before I began to realize that my mythology was misguided, or at least naive. The small, high desert town was surrounded by vistas that looked like the backdrop for a Hollywood Western—both *There Will Be Blood* and *No Country for Old Men* were filmed there the year before—but I started to suspect that the landscape's aesthetic connotations of freedom didn't necessarily mean I was any more free, and that the absence of crowds didn't mean that I was any less observed. I had to quickly adjust my expectations when people I was meeting for the first time seemed to know all about me. *I've seen*

your Volvo around, they'd tell me. But how did they
know? I learned that they all reflexively kept tabs
on each other: who had just returned from a trip out
of state, who was parked outside whose house, and
who drove what. A friend who'd lived in Marfa his
whole life told me about how when he was in high
school, he and his friends would cruise the farm
roads after Friday night football games; there were
so few of them that they could recognize one other
a quarter mile away by the distinctive shapes of
their headlights.

I started to sense that I was being watched
whenever I left my house. There were no anonymous
spaces, no ways to be in public without being subject
to (a mostly benevolent and low-key) surveillance.
The feeling wasn't entirely unpleasant–I'd place it
somewhere between cozy and claustrophobic–and it
was a welcome change from my urban conditioning
of always being in a crowd, seen yet unnoticed. But
it was also unsettling. That first month, my unease
revealed itself in dreams. I had my first social surveil-
lance nightmare, in which I was perpetually running
from sinister government agents in bespoke suits.
Whenever I escaped to a new location, they'd see my
car parked outside and come after me.

Debates about the use of public space usually pre-
sume an urban context and center on a city's plazas
and parks, places that have historically accommo-
dated many uses by many types of people. These
kinds of public spaces are where disparate popula-
tions intersect, where "the stranger feels at home,"
according to urban sociologist Ray Oldenburg.
These qualities of openness and mutability are
rarely accepted without conditions–hence the long,
entwined history of public space, surveillance,

anonymity, and policing. In English Common Law, the basis for the legal code of the United States, the earliest forms of policing public space came in the form of vagrancy laws—a vagrant being by formal definition a person who was unable to give an account of himself. These days, one of the most pressing questions regarding the use of public space centers on the role of surveillance, and whether the potential gains in increased security are worth the trade-offs—lost privacy and increased power ceded to police and other authorities.

Over recent decades, advances in technology have led to more sophisticated—and increasingly normalized—forms of surveillance. The daily movements of Londoners are captured by an estimated half a million security cameras, one for every fourteen people, and other cities have followed suit in investing in CCTV systems. Dragnet surveillance—that is, blanket information collection—is becoming a standard practice in many urban areas, where large proportions of the public often approve the use of heightened surveillance. Shortly after the Boston Marathon bombings, a national survey showed that only one in five Americans opposed the use of security cameras in public places. The prevailing theory is that public places require certain levels of policing and monitoring to keep them safe, to prevent the small percentage of criminals from damaging the experience of the majority. Of course, the actual implementation of surveillance is complicated and fraught with political connotations. But many accept the panoptic logic that covering cities with CCTV cameras can effectively reduce crime, holding fast to the belief that bad actors are less likely to act badly if they recognize that they're being watched.

One thing about security cameras is that they tend to announce themselves, often manifesting just above our heads as ominous, silver-black orbs or disc-like convex mirrors. But not all surveillance is quite so visible. In 2014, the *Washington Post* reported that the US Army would be installing two tethered surveillance blimps on a patch of military-owned land between Washington, DC and Baltimore; the aerostats, as they're called, are equipped with radars capable of tracking as far south as Raleigh, North Carolina, and as far north as Boston. The aerostats' ostensible purpose is to watch for cruise missiles or enemy aircraft entering domestic airspace, but the Army has refused to rule out equipping them with the kind of high-altitude surveillance systems or infrared sensors that can be used to track individual people and cars, even from an altitude of 10,000 feet. The Army also claimed "no current plans" to share the information its aerostats collected with law enforcement—which is perhaps why some local governments have begun looking into investing in persistent surveillance systems of their own. In the summer of 2016, citizens of Baltimore (and even the city's mayor) were surprised to learn that for the past eight months, a Cessna equipped with an array of cutting-edge cameras had been flying over the city for up to ten hours a day, capturing detailed footage of everything taking place in a thirty-square-mile area.

When the news of Baltimore's secret surveillance planes surfaced, I was troubled but not shocked. I suppose that by now I've been conditioned to expect that when I'm in a city, I'm being watched. What has surprised me, however, was coming to realize how much surveillance was a part of my daily life in the rural Southwest. Years

before Baltimore's secret surveillance plane took its
first flight over the city, predator drones flew over
Arizona's Sonoran Desert, equipped with video
and motion capture technology. And every time I
drove west out of Marfa, I passed by an aerostat just
like the ones recently installed on the East Coast.
Our local surveillance blimp has been in place
since 1989, and is managed by the US Customs
and Border Patrol (CBP). On bad-weather days it's
grounded and sits outside its hangar; other times the
CBP lets it out on its tether and it hovers in the sky,
a small speck visible from miles away that sabo-
tages my sunset photos. *Is that an art installation?*
more than one tourist has asked me. I can under-
stand the question; up close, the aerostat looks so
benign, *cuddly* almost, like an orphaned float from
a Thanksgiving Day parade. But it is more substan-
tial than it appears; the high-tech zeppelin and its
seven counterparts positioned along the US/Mexico
border are equipped with radars weighing more than
a ton, capable of detecting low-flying aircraft within
a 200-mile range. There are other, smaller aerostats
keeping tabs on ground traffic in the border region,
too, the people and vehicles moving through the
area—technological veterans of the wars in Iraq and
Afghanistan, complete with bullet holes.

In fact, much of the surveillance equipment
used by CBP along the border are military hand-
me-downs, or adaptations of technology originally
intended for use in the Middle East. As resources
(and funding) begin to shift away from wars in
Iraq and Afghanistan, defense contractors began to
consider how to make money closer to home, Todd
Miller explains in *Border Patrol Nation: Dispatches
from the Front Lines of Homeland Security*. "We are
bringing the battlefield to the border," Drew Dodds

told Miller. Dodds, a former Marine, is now a sales-
man hawking a mobile surveillance system called
Freedom On-the-Move, essentially a truck bed fea-
turing a periscoped camera that can be maneuvered
by an Xbox controller, and which provides "spot and
stalk" technology to track migrants moving across
the borderlands. Such technologies are also making
their way to urban police departments. And so if you
want to understand the future of what surveillance of
urban spaces might look like, the best place to look
might actually be the rural Southwest.

Rural border surveillance also takes advantage
of other cutting-edge technologies, as well as social
trends like crowd-sourcing and gamification. From
2008 to 2013, the state of Texas funded an innova-
tive program centering on participatory surveillance
of rural border areas. It was meant to address a
particularly contemporary problem: an abundance
of cameras and a dearth of people to monitor them.
RedServant, a technology start-up based in a small
town 200 miles east of where I live (and whose name
sounds like a militia dreamed up by PlayStation),
enlisted civilian volunteers—referred to as "virtual
police officers"—and provided them with free, 24/7
access to the more than 200 video feeds and sensors
installed along the border with Mexico. When users
saw something suspicious, they could click a red
button to alert the local sheriff's department, which
would go investigate. RedServant's interface was
designed to make surveillance seem like a game, sim-
ilar to military training technologies modeled after
video games. Users could choose between a number
of real-time surveillance cameras, each "virtual
stakeout" with its own objective: *Look for individuals
on foot carrying backpacks. Please report persons
on foot and vehicles that are parked along road.*

"Even though I was morally against the purposes of the site, when something would move, or human activity would appear, I felt compelled to press the red button," wrote Spanish artist and researcher Joana Moll, who spent three years researching RedServant. "Once immersed in the logic—and by extension—the rules of the site, it felt like the right thing to do …. The interface, along with the camera feeds, allowed to physically decontextualize the border and bring it to the user's private sphere in the shape of a game." Over the five years RedServant's participatory surveillance program was operational, more than 200,000 people took part, effectively donating nearly one million hours of labor to the sheriff's department, and resulting in 5,331 interdictions. (The company was paid $625,000 per year by the state.)

And so surveillance technologies follow an established path, from the battlefield to the border to the city. And the free and open West, the rough terrain that symbolizes rugged individualism and American self-invention, may actually be the most closely watched territory per capita in the country.

Midway through my road trip five years ago, I was zipping through the high desert just past the line that marks the shift from Central to Mountain Time, where the land does indeed start to become steeper and craggier. Even though I was on Interstate 10, a major national highway, the road was still empty enough that I could let my mind wander. And then, seemingly in the middle of nowhere, a confusion of lights and orange cones: my first border patrol checkpoint.

It caught me off guard then, but I soon learned that in 1976 the US Supreme Court authorized

random-stop checkpoints within 100 miles of the US/Mexico border. After five years of road trip interruptions, the checkpoint routine has become familiar to me, though still always tinged with anxiety. Cars heading south or west can generally zoom on through the checkpoint, although a camera will record their license plate numbers; those heading north or east, though, have to stop. The procedure follows a predictable pattern: while a German Shepherd sniffs your hubcaps, a young man in a uniform begins asking questions: *Are you a US citizen?* Everyone says that's the only question you're legally required to answer, but the checkpoint agents often seem bored and eager for conversation: *Where have you been? Where are you going? Do you live in Marfa? Do you like it there?* I fantasize about replying with stony silence, but a certain submissiveness inevitably bubbles up when I'm faced with authority, and I always answer, despite myself. *Just heading home*, I say. *Yes, it's an interesting place to live.*

People who don't spend much time in the Southwest are often surprised by these checkpoints. They probably think, as I did when I first moved here, that border patrol checkpoints are something that exist at the border, and that the border is a line between two countries, and that it is easy to tell which side you are on. The checkpoints complicate the Great American Myth of the free and open road. ("The mixed blessing of America is that anyone with a car can go anywhere," Paul Theroux wrote in his 2009 account, "Taking the Great American Roadtrip," concluding that "the visible expression of our freedom is that we are a country without roadblocks.") But as the checkpoints make clear, the border is increasingly a zone, not a line—or perhaps even a mentality, a net of assumption and suspicions.

And so the people driving on the public roads and highways of the Southwest are subject to heightened scrutiny, and the border patrol checkpoint is becoming just as much a part of the American road trip as gas station coffee and tumbleweeds. In the borderzone, you should be prepared to give an account of yourself. And, as Miller notes, the borderzone is always expanding.

Clearly, this stylized, road-trip West is an invention. Like it or not, we live in an era of mass data collection, new surveillance technologies, and expanded police powers, an era when social media allows us to obsessively keep tabs on ourselves and others. Yet we also continue to contend with a centuries-long daydream that imagines the American West as the territory for all our escapist fantasies. Just as the European colonists chased visions of resource-rich, rule-free, inexhaustible land, some contemporary city dwellers see the West as a place to stock their Instagram feeds with images of canyons, cacti, and other symbols of freedom and exploration. Ironically, this enduring belief in the mythology of the West—and the disregard for its surveilled reality—threatens to undermine the very freedom that many ostensibly valorize.

This all may sound bleak, but it doesn't have to be. While at first I found the social surveillance of my small Western town to be unsettling, I've grown to appreciate it. We return each other's lost dogs; we notice when someone is struggling. The difference, of course, is that we are all in it together—we're watching each other watching each other, a circular system that provides for a level of mutual accountability.

It's clear that surveillance on the part of the government, the military, or corporations is a different

animal. What's also becoming clear is that we have
every right to demand similar structures of account-
ability in these situations, too. The checkpoints and
surveillance blimps are there. Rather than cropping
them out of our mental pictures (or gleefully aesthet-
icizing them as art), we need to keep an eye out for
them. We need to *watch back*. That means paying
attention to what is being authorized, how it's oper-
ating, who's paying for it. In looking closely rather
than looking away, we can begin to create a culture
of accountability, rather than one of denial. This
will likely require letting go of cherished notions of
the West as a place where we can live freely, where
we can "do anything." Those wide-open spaces may
have once looked like freedom, but they arguably
never really were. In today's technological landscape,
these spaces provide the best sightlines: when there
are so few people around, it's easier to zoom in.

LAWRENCE WEINER

GOLD
SILVER PER SE
EMERALDS

STEEL
SALT PER SE
DIAMONDS

MOVED
CARRIED PER SE
PLACED

Por Si Mismo, Palacio de Cristal, Madrid, 2001

Final Report

China Miéville

Listen. Normally I'd send this but I want to give you my report in person. When I'm done you'll understand why.

Remember the morning you came in? Some regulars sat in the waiting room with you: Dwayne, leaning on his fold-up cross; Shya shuffling mandalas; Violet in her neat best, smiling and muttering. And there you were, clutching your bag, staring at the cheap TVs I'd tuned silently to religious channels.

I called Violet in and while she chatted I found your initial email and Googled you. That's how I found out that your usual style wasn't that button-down but band T-shirts and riotous behavior. Every time you got arrested your neighbors told the papers you were a lovely young man.

Sorry, I said, when she was done and it was your turn. She was talkative today.

Violet's husband, John, pastor of a little spiritualist church, had died very recently. She needed someone to talk to—someone other than him, I mean, which she continues to do.

A lot of what I do's just listening, I said.

But not always, you said. You used to be a cop. And before that … you know what they call you on the forums?

They call me the Bad Habit. After I left the convent, I was police for a while, and good at it. I still have skills and contacts.

I assumed what you had in mind from what you were saying. You need to understand, I said, most people don't want "rescuing" from whatever sect they've joined, so my job doesn't stop after I get them out for you. That's where the listening comes in. And the few who are eager to be convinced out of belief, I'm well-placed to help. They need someone who understands faith.

That's what I need, you said. Exactly that. But it's too late for a rescue.

Intrigued, I told you I could help with cult research, textual hermeneutics, comparative theology. Whatever's necessary, I said. I'm a faith consultant with a broad remit. So what can I do for you?

It's my sister, you said. You began to cry. She was murdered.

You struggled to get the story out. Weeks ago, your sister Sarah was found dead in a blood-soaked chair in her university library. She'd been working late. Someone had grabbed her from behind and cut her throat.

I looked it up as you told me, and there you were, listed as grieving family–this time under your given, less outré name.

Sarah was older but so close to you in age you'd more or less raised each other since your late teens, when your parents died. You were both driven– orphanhood, near-poverty, who knows?–but Sarah in the direction of school, church, business, while you took your route, and your rap sheet built up.

The *police*, you said with disgust, have nothing. No arrests, no leads, no ideas. Because they don't understand. They can't find any motive. They didn't see how she was getting, so they're not looking in the right direction. Someone killed her, you said, because of her religion. To find out why I need someone who understands faith. Who understands hating it.

You'd brought me her laptop, the papers you'd found in her apartment, a list of her friends.

She'd worked for Yosep Development, the huge London-based property company, for years. In her early twenties she'd interned at their offices here in

New York, got in at the ground floor, had been doing extremely well. I could trace her professional trajectory in the quality of the business cards you showed me, her increasingly impressive titles under the stylised Y logo. Sarah Sams, I read, Strategic Projects. She was ambitious: she'd been in that library working on her MBA—which Yosep were funding, generously. I skimmed a couple of her formidable essays on branding, portfolio-building in public services, aggressive expansion, competitive tendering.

I read your emails with her—her polite, smart orthodoxies when you accused her, all-caps, of being a FUKKEN BIGOT. You excoriated Yosep's price-gouging, the gentrification it trailed, its pursuit of "Private Ownership of Public Space" schemes, buying up plazas and parks from local authorities, and what interested me was that you didn't attack Sarah's faith, but her interpretation of it. You quoted Dorothy Day, liberation theology, the Berrigan brothers. To which she responded with pro-market Catholics like the Acton Institute, Thomas Woods, the later Robert Siroco.

You said, She always had God—I got out of that years ago—but in the last couple of years, it got crazy intense. Scared me. She got weirder and secretive and excited. Something was up.

She kept asking you to come to the Catholic study group she'd joined at university—The Bible, Catherine of Sienna, Augustine, several weeks on Dante—to have this out in person. You never went.

Her politics had gotten so horrible, you said. I loved her. But, man. My friends were surprised I could stay close to her. But … you shrugged.

When cancer took my mom, I told myself that it wasn't that I lost my religion; I just realised I'd never had it. That it was *her* faith I'd committed to. She

was the one who'd wanted to be a nun back in the
day. We didn't have much in common, either. But
the thought of her last days, her open eyes staring,
yearning, still hurts me. I empathized with your grief
and your love.

I charged you next to nothing. You'd got my interest.

I called in favors, got copies of evidence forms
from bored desk sergeants. I spent half a day wan-
dering the grounds of her school, past buildings
emblazoned with the names of sponsors. I tracked
down her classmates and flashed my fake police ID.
Just a few more questions, I told them.

Even those with whom she'd–brutally, I gath-
ered–debated, spoke of her with a respect they
obviously found consternating, bordering on awe.
She was so smart, one guy told me. And calm. And
… He struggled to explain. She seemed like a really
good person.

You liked her, I said.

Fuck no, he said. I did not. That's not what
I'm saying.

You should talk to Diana Costello, he told me.
That was a name you'd given me, a student in
Sarah's Advanced Negotiation class. I found her
in the campus coffee shop, a tall, shrewd-looking
young woman with an expensive haircut, reading
a book on outsourcing. Diana's marks came close
to Sarah's but didn't meet them, so in my mind I
was auditioning rivalry as a motive, but her distress
seemed as legit as yours.

I could tell she was nervous, as well as grieving.
I loved her, she said. We collaborated on projects
together. We worshipped together.

Sarah brought you in to the reading group,
didn't she? I said. Diana nodded.

Did anyone ever get up in her grill about that stuff? I said, though it seemed more likely she'd have been up in theirs. Any confrontations? Evangelicals, conservative Muslims, Dawkins-bro atheists?

Diana mumbled that she didn't know and she wouldn't meet my eye and I couldn't persuade her to tell me whatever it was that she was holding back. Eventually I took her phone number and her address and told her not to leave town.

She'd got me thinking. From Sarah's emails I got the list of everyone in the reading group. One name I didn't remember from the police interviews.

Neil Tyne had only been at the university a few months, but he seemed to take a leading part in the group's discussions. He wasn't a student though: he was a teacher, the convener of the Negotiation and Marketing courses. The day Sarah was killed, he'd been out of town at a conference, his schedule said, and two days afterwards, his car was found overturned and burned out at the bottom of a ravine off the interstate, shredded tire and broken railings above, and the crushed, charred remains of a body inside. Neil Tyne had been declared dead, with a posthumous alibi.

His digital footprint was light. I found a few photos of a broad-shouldered, clean-shaven man a little older than me. Tyne graduated in Economics in the early '90s, worked in property management, bouncing from company to company, including Yosep, then as a consultant. Mid-naughties he'd finished a DPhil at Oxford ("Strategy and Bargaining in Emerging Markets"), going into academia just before the 2008 crash. Before this New York job, he'd been at a business school in Sydney.

I listen to intuition. To inspiration. I kept look-
ing. It was while he was in Australia, I discovered at
last, after two days of searching for I knew not what,
that another of his students had died.

David Mayor, too, had been smart, conservative,
building a business career, active in the Catholic
Society. Unlike Sarah, he had a reputation as a
party-goer, a sleeper-around. It was during a
drunken skinny-dipping escapade one balmy night
at Lake Yarrunga that he'd drowned. A very sad
accident. No one thought anything else.

But I had an itch to keep looking now. Before
Sydney, Tyne had been in Boston, the Emirates,
Switzerland, Russia, the UK, and elsewhere, never
spending more than a year at any institution, and
often much less. You'd think that would put employ-
ers off, but he kept getting jobs.

I searched the press in every city he'd been in,
over the months he was there. In Bern, a young
man died in a botched mugging, his mergers text-
books spilling across the street. In Moscow, an
allergic reaction took another's life. A car crash
killed a high-flying Masters student in Dubai. Back
and back and back I went. I stopped counting
after ten.

Everywhere Neil Tyne worked, days or weeks
before or after he moved on, a student in his depart-
ment died.

I was tracking a serial killer.

I collated information, read obituaries and remi-
niscences on forums. All the dead were successful,
right-wing, and Christian—if, it seemed, a flawed and
worldly lot, remembered as full of excesses, fighting,
fucking, even embezzling.

And all were on scholarships.

I remember holding my breath as I teased apart the finances of the groups providing the money, tracing them back through holding companies. Because what became slowly clear was that ultimately, every dead student had been supported by Yosep Development.

Do you wonder why I'm only telling you this now? I'm simplifying, obviously: all this came way less smooth than I'm describing it. And this was about when you and your crew got arrested on that anti-yuppy march in San Francisco, after you smashed up that realtor's office. I skimmed your timeline with all its hashtags–#gentrifythis, #accessallareas, #occupyeverything.

I gave you a little cheer: my Mom was a Vatican 2 person. While you were busy, I kept looking.

I searched Tyne's history for something to explain such lethal rage. A spectacular firing or humiliation. Anything that might provoke this grudge, against capitalism, or this very company, or Christianity, a mission that, though I couldn't prove it, I was sure he'd fulfilled more times than I could count.

I found nothing.

Perhaps, I thought, he considered himself the real Christian, taking care of these hypocrites and sinners. But Sarah broke that pattern: agree with them or not, everyone said she was rigorous about her own morals. And why, after so elaborately disguising all these other attacks, did he kill her so overtly? Because I'm certain he never arrived at his conference. That he was in the city, murdered her, then drove frantically to be where he'd said he would be. Only to plunge from that raised road.

That thought immediately made me nervous. I went back to the file. The body in Tyne's car had been severely damaged. Beyond dental records.

With a sick, urgent feeling, I went looking for leads back in that tangle of financial aid. I found one much more quickly than I thought I would.

Just after midnight I snuck past the doorman of the swanky apartment block where Diana lived on the top floor.

I knocked, whispered her name, waving at the spy hole. You're not answering your phone, I said. We need to talk.

When at last she opened the door a sliver I pushed my way right in. She backed away, shaking, clutching her phone, her eyes and mouth huge.

Listen, I said. Yosep's funding your studies, right? That makes you a target. I can't explain why, I said, but I think Neil Tyne's still alive.

Her face didn't change. She looked up at a crucifix on the wall, back down at me. She seemed stupefied with terror.

You know, don't you? I said slowly. I came closer. You know Tyne's alive.

She blinked. She looked down at her phone.

God damn it, I said, and snatched for it. She let me take it.

On-screen was a day-old text from one "NT." *Now*, it read. *Go to the woods.*

This is from him, I said. What is this?

Help me, she said. He's waiting.

For what? I said.

From behind me came a man's voice. It said, For her.

I was still turning when Neil Tyne hit me.

I was tougher than he'd estimated. I came to seconds later, in pain, lying on the floor, watching from my side while he advanced and Diana cringed by a window. Everything sounded distorted to me. I tried to rise.

You promised, he was saying to her. You got my message.

I don't want—she whimpered. He interrupted.

I've been waiting outside, watching, but instead of what I'm waiting for now I see her come in? Why did you call her?

I didn't! I don't know why she's here … but … I changed my mind …

I was fumbling in my jacket.

What? He was disgusted. Do your job. He snarled something at her that I couldn't make out, about something animate, calling her an officer.

I got to my feet and drew my pistol. Hey! I shouted.

But even as I said that he lunged forward and put his hands on Diana's shoulders and shoved and sent her smashing backwards through the glass.

She didn't scream on her way down.

Don't fucking move, I said. Tyne turned to me. My aim was steady.

Who are you? Tyne said. He seemed thoughtful. I heard someone was poking around, but I wasn't expecting this.

Put your hands up, I said. He didn't obey. Why'd you do it, you bastard. I kept my pistol pointed right at his chest.

Well, Tyne murmured. He seemed tired. He looked as if he was thinking things through, sounded as if he was talking to himself as much as to me.

Can't hurt to cover the outskirts. Or the ditches, he said. That does still leave the woods.

Hey, I shouted, and he looked right at me.

I can't tell you exactly what happened then.

I stood yards from him. I had him in my sights, my hands braced and steady. I saw his eyes close and his lips move. I saw him whisper.

And then I didn't have my gun any more.

Tyne had it. He was aiming it right at my face. I don't mean he aimed it at me, I mean he didn't have it then no time passed and he did have it and he was already aiming it at me.

I staggered. I gasped and stared into the muzzle and then up at him. He was so calm. I saw him make a decision. He gave me a tiny smile, so I got ready to die.

And then he put the barrel into his own mouth. I swear to you I can only describe his expression as he pulled the trigger as *wry*.

I didn't wait for the police. I got out fast.

So am I here to tell you that your case is closed, now Sarah's murderer's gone?

When I was staring at the mess of blood and brains, all I could think was that Tyne was dead now—really dead, this time, no question—but that nothing made sense. You didn't just ask me to find out who killed your sister: you asked for an investigation. You asked why.

For hours afterwards I could only walk back and forth in my office, trembling in shock, pacing past the graphics and agitated ranting pastors on the televisions in my waiting room. I kept remembering that adrift instant, the feeling of my fingers gripping my gun—then closing, because it had gone.

Think, I kept muttering. I needed a way in. A trail to pursue.

OK, I said. OK. Let's go over it again. How was Tyne, an academic who didn't publish, who was barely more than a few months in any position, able to get serious jobs at serious institutions.

Follow the money. It's always–always–the best advice.

So I called in a favor with a shit-hot accountant of my acquaintance who wasn't glad to hear from me. This has us even, ok? he said. He messaged me two days later with what he'd found.

Of course, universities get money in all the time, but here my guy's forensics came in. Because amid the wash of dollars, he'd isolated something interesting. For the last decade, every institution that hired Tyne, within six months of doing so, received an unheralded major one-time donation– never less than a million, often a lot more. No wonder normal hiring protocol got relaxed, with this reward.

And what all these apparently distinct grants and philanthropic gestures and funding streams from various sources had in common, other than that timing, was where you ended up if you traced the financial shell game back. Again, every donating body was ultimately owned or substantially funded by one organization.

Yosep Development.

Tyne wasn't trying to destroy Yosep or punish it: it was bankrolling him.

I was having very bad dreams.

I was looking into who was on Yosep's Strategic Projects group, to which your sister was seconded, when you got out and started messaging me for an

update. You remember I stalled. I was texting you when of all people Violet, my widowed client, came shyly into my office.

Oh, she said. She smiled. Her voice was all quavery, nervous. I was hoping we could have a chat, she said.

My eyes were crusty and my stomach was empty and I couldn't deal with her.

I thought, she said, you might be able to help with a problem—

Goddammit Violet, I said, I don't have time for your problems.

She stared, retreating. I felt guilty at her shock.

It's not *my* problem, she said as she closed the door behind her. It's my husband's. Something's blocking his way. Saying now he has to pay a toll.

And there was something about hearing her say that, about what she said, how she said it, that made me look up and follow her into the corridor. Something that put me in mind of something *else*, something that set a lot of things I hadn't known I'd been thinking into a new configuration.

I stood staring at the televisions again, trying to recall what it was I'd recently glimpsed on an eccentric channel. I clicked through into the wilder stations, cheap apocalypse-mongers recorded on bad equipment in ugly studios, all brimstone and demons. I turned the volumes up and competing prophets ululated and demanded money and itemised their outsider visions.

It took hours to find it again. I was patient.

And as you burn, I at last saw one man shout in Holy Ghost tones, you'll see new shapes in the fire, in the lake of pitch, a new escutcheon rising in Hell. His eyes glazed and he looked, for an instant,

quizzical. A Hebrew letter, he said, *Tsade*, which means *need* and *desire*–

He kept going but I stopped listening. I just watched as he drew the letter with his finger.

What he saw in his dreams might have been a Hebrew *Tsade*. It also looked like a Y.

Tyne never said "animate" or "officer." What he said to Diana was *l'anima tua è da viltade offesa*. Your soul has been assailed by cowardice. Canto II, the *Inferno*.

It's in Canto III that he shows us the miserable souls stung by insects in the dust outside the gate, by the shores of Acheron. Those too fearful to commit to good or evil. Too fearful, perhaps, to keep their word.

Can't hurt to cover the outskirts, he'd said, when he killed Diana.

Or the ditches. Because if she'd never even intended to keep her promise? In the tenth trench of Malebolge, the eighth circle of Hell, devils watch liars get ravaged by disease.

Do your job, he'd said. And sent her to work.

He still needed someone where she'd been supposed to go. He took my gun. It's only one circle away from hers, the Forest of Suicides.

They'd been studying the map for a long time, preparing for exactly these negotiations with these exact authorities. All the Yosep agents in all the circles– the lustful, the proud, the gluttonous–all hammering out proposals and counterproposals, to bargain with Minos and Cerberus, Plutos, and Geryon. They could meet up again, Tyne and Diana, make their way together, when the commons of damnation are privatised. And punishment outsourced.

What do you think Yosep are paying for these
rights, to this property, as their logo goes up in the
streets of Dis, glows above Satan, reflects in the ice
that binds him?

And in what coin, I wondered as I watched that
screen, are they making a profit?

As soon as I thought that question, I closed
my right hand, remembering what happened to my
weapon. He has to pay now, Violet had said of her
dead John in his own nebulous afterworld.

What else do the dead, or those with dominion
over them, have to offer but their intercession?
Attention from beyond. Miracles.

Incompatible things can all be true—both Diana and
Violet right. And no truth's eternal, times change,
and systems with them. I realized that when I left my
order. Perhaps atheism was right, once.

A temple went up west of Bangkok last year.
I've seen photos. In one corner of its garish mural of
postmortem torments of *Naraka*, above the roasting
dead, is a flag. On it is a Y. That sign's suddenly
started appearing in the eschatology of a lot of faiths,
marginal and not.

I found out who's on the board of the Strategic
Projects group. Economists, management scientists,
financiers, of course. And there's also a rabbi. Two
imams. A Catholic bishop and several priests. Of
various denominations, in fact. Of many religions.

Emerging sectors are brutal. It can't be long now till
Yosep's competing with other companies, if it's not
already. Maybe that's why Tyne went to the woods.
They need their best people in place.

He hadn't bothered disguising Sarah's murder;
just bought himself some time with that cadaver in

his car. Because things are finally entering their most important phase.

Because Sarah was special. As you've told me. As everyone says.

Yosep obviously built up its portfolio starting with less desirable property—less costly, less exclusive, much, much easier to get representatives into, on the ground, to deal with various local executives. But, after a long search, Tyne found in her someone who had not only the necessary strategic skills, and commitment to the project, but was able at last to go, not downtown, but up. Straight to the prime, desirable real estate. To start negotiations with the CEO himself.

And that's why I'm here, telling you this, with my gun aimed at your heart.

I'm sympathetic to your points of view, I told you. Bad enough below, let alone in the new investments above. I won't have my mother held back from access rights to the light. I know her: she wouldn't pay whatever they charge, on principle. She could make me crazy, like your sister did you, but she was a good person.

Like Sarah. Like you.

Please don't tell me you're an atheist. Maybe you even believe it, but I've read your emails. I know that you've no more put faith aside than, it turns out, have I.

I'll send others soon. I've a list of radical priests to visit, when we're done here. But you—you don't just have the right politics: no one knows or understands the enemy better. The negotiator. You know exactly how she works. You can lead.

That's why I'm here, with you, raising my weapon, now you understand what you have to do.

Hush. There's nothing more important, is there? No fight's more vital. Are you ready?

Occupy hereafter.

LAWRENCE WEINER

PLACED ON EITHER SIDE OF THE LIGHT

Walls in the Street, Beobanka Building, Belgrade, Serbia, 2009

Sensory Navigation in Hong Kong

Christopher DeWolf

It's easy to get lost in Hong Kong. The hilly, crowded streets disorient, each one a lookalike jumble of shop signs and concrete blocks. Noise bombards you from every angle: rattling trams, roaring woks in open-front restaurants, the distinct clanging sound of pedestrian crossing signals. Incense smoke wafts through the streets from tiny shrines and big temples; frying garlic and stinky tofu are blasted out from exhaust vents. Even when you do manage to get your bearings, your path takes you underground, into a shopping mall, or across a footbridge that throws you off yet again. In Hong Kong, it's not enough to know where things are; you have to know how to get there, which can vary wildly depending on your point of origin. The Hong Kong flâneur knows that many spaces double as passageways, and passage-ways can be destinations.

Hong Kong can look like a modern city plan-ner's nightmare. Founded by the British in 1841 on a rocky island that had until then contained only a handful of small fishing and agricultural villages, Hong Kong was chosen primarily for its strategic location near the mouth of the Pearl River, not for its suitability as a settlement. The early city was laid out along a series of switchback roads connected by staircases; new land was created by leveling hills and dumping the soil into the harbor. These geo-graphical constraints created a city that looked not unlike an Italian hill town: a tangle of tenements that clung to the slopes of Victoria Peak, their tile roofs and stone walls interrupted by narrow streets thronged by street vendors.

After World War II, a new layer of modernity was imposed on this thicket of nineteenth-century urbanism. Modernist skyscrapers were built on flat land near the harbor, connected by above-grade

podiums and footbridges that plugged into the hill-side streets of the old city. On the outskirts of Hong Kong, huge new housing estates emerged from shantytowns built by the roughly two million refugees who fled war, famine, and political persecution in China. Building regulations were lax in the postwar years and developers built enormous blocks where apartments, businesses, and small factories coexisted. Even as building codes grew more restrictive, city planners gave landowners wide latitude to develop their properties as intensely as possible. Hong Kong grew taller, denser, and more intricate with every passing year.

In the more typically conceived city, there is a clear distinction between the built environment and natural topography. You can see where the street ends and a park starts; there is space to behold important landmarks. Hong Kong mashes everything up into complex three-dimensional networks of urban space that blur private and public spaces. Public parks exist on top of and within buildings; a single building might have entrances on multiple levels. One of the city's earliest skyscrapers, the Hopewell Centre, was built on a slope so steep that the tower actually has two ground floor entrances: one on Queen's Road East and another, ten stories up, on Kennedy Road.

A simple A to B journey through the city involves traveling across multiple levels and through publicly accessible spaces of varied ownership. Walking from the High Court to St. John's Cathedral, you pass first through a shopping mall, then a public park, which leads seamlessly onto a footbridge that takes you into a lobby of an office tower, which deposits you onto yet another footbridge. After walking through the humid tropical foliage of a privately owned, publicly

accessible garden, you finally glimpse the pastel yellow façade of the 175-year-old Anglican place of worship.

This is a phenomenon that architect Jonathan Solomon calls "a condition of groundlessness." In his book *Cities Without Ground*, co-authored with Adam Frampton and Clara Wong, Solomon observes how Hong Kong has evolved into a striking contradiction to the idea of urban order codified and spread by Western societies. In response to extreme factors—namely a constrained site, a mountainous topography, and a thriving population, part of which is plugged into the network of global finance—Hong Kong has developed a complexity of urban form that is legible only to those who have developed a sense for it—quite literally so. To navigate through the city is to rely on sound, smell and touch. "You have this hierarchy based on other senses," says Solomon. "You know when you are in a high-end shopping mall when the air is cool and dry and perfumed. Then you realize you're in a transit space when things get a little bit warmer and noisier and the materials are a little less reflective." Hong Kong is a visceral city, a city that forces its inhabitants to reconsider the primacy of sight as the primary frame of urban experience. As such, it is a city that tests our outsize dependency on vision and offers alternatives to it.

Western thought has long privileged sight over other senses, and this bias has affected centuries of cultural production, not least in architecture and urban design. In both its design and its discourse, modern architecture in the Western tradition has emphasized visual order and rationality, speaking to an audience that often shared the same prejudice. Still today, it's hard to ignore an ugly building, but unpleasant sounds or smells are often unconsciously

redacted from our perception of our surroundings. In Georges Perec's 1975 *An Attempt at Exhausting a Place in Paris*, the French writer famously describes the scene from various Parisian café terraces with laborious detail, but almost never makes note of his aural, olfactory, or haptic observations. Whole dimensions of urban life are left conspicuously unexhausted.

In 1967, Michel Foucault introduced the concept of the heterotopia as a space between the physical and the psychological. In a heterotopia, different places are juxtaposed within a single physical location. For instance, the hybrid physical and psychological space you occupy while talking on the phone can be a heterotopia; the metaphysical space of a garden, which is at once a real, physical environment, the representation of other historical or geographical locales, and a microcosm of a natural ecosystem, is also heterotopic. The concept is a useful way of considering the role of the senses in urban space. The musk of a moldering old public housing estate, the distinctive clacking noise of pedestrian crossing signals, and the bittersweet aroma of medicinal, Chinese angelica can trigger emotions and memories that create a sensory map of our environments.

There's a scientific explanation for this: as research has shown, the same area of the brain that processes sensory information also stores emotional memories. The city's sensory landscape therefore not only helps us understand our surroundings in a practical sense but also creates an emotional prism through which we refract our experience of the city. Our visual memory eventually recedes with time and age, glossing over details and wreaking havoc with proportions. But our sensory memory evokes spaces

that have likely changed or even ceased to exist. The old Central Star Ferry Pier was demolished in 2006, but I can still remember the musky scent of its mildewing walls, the sound of the mooring lines being tightened as a ferry docked, and the springiness of the gangplank as passengers boarded the boat. In acknowledging that space is experienced through a range of senses, many of which are linked to memories, we can begin to conceive of space as something always more than a sum of its parts.

Hong Kong is rife with opportunities to meditate on the city's auditory, olfactory, and haptic experience. Some of the most interesting maps in *Cities Without Ground* are visualizations of the temperature in Hong Kong's interconnected, three-dimensional spaces. On a hot summer day in Central, it varies from 33.6 degrees Celsius on an exposed concrete plaza to 27.1 degrees under the stone colonnade of the nineteenth-century Court of Final Appeal. Indoors, temperatures dip to 20.5 in the excessively air conditioned subway cars of Central Station and soar to 35.2 in the poorly ventilated bus terminus of Exchange Square. Just as perceptible is the humidity. The air inside Pacific Place, a high-end shopping mall, is dry and crisp, but it is heavy and lifeless inside the bus terminus nearby.

Hong Kong's urban spaces do best when they are allowed to become a palimpsest of human activity. The area around Choi Hung, in working-class East Kowloon, is a mess of postwar housing estates that collide with old villages and busy roads. It looks confusing, yet the density of human activity makes it easier to navigate than you might expect. Emerge from the subway station and you will encounter the roar of traffic, the choking exhaust of minibuses and the amplified cries of touts selling mobile phone

plans. A flow of people carries you up a footbridge and across the road, where you enter a public market, its air pungent with ripe fruit and huge slabs of pork hanging from hooks. A few more steps, past the click-click-click of escalators, and you emerge onto the main street of Nga Tsin Wai Village, a pedestrian promenade lined by restaurant terraces, with their clattering dishes and chattering customers. Take this route more than once and its visual landmarks become almost secondary: your other senses pick up the slack.

"People don't have strong memories of neutral-scented spaces," says Virginia Fung, an architect who researches sensory urbanism at the City University of Hong Kong. "It is more memorable in the streets, with these multiple senses, but these places are diminishing and being removed." Like all cities in the era of late capitalism, Hong Kong's diverse landscape of street markets and small businesses is ceding ground to the homogeneity of chain stores and tightly regulated upscale shopping malls. High rents create a revolving door of businesses—just when you get to know the Chinese medicine shop on the corner, it closes and becomes a 7-Eleven, which only adds to the disorientation. In Hong Kong, the social and economic terrain doesn't just shift—it roils like the ground in an earthquake. This raises the question of how to conserve the sensory heritage of a place, and whether it should be conserved at all. Old buildings can be maintained, but what about the more ephemeral sounds and smells that gave them life?

There are a few interesting experiments in this regard. In an old working-class corner of Wan Chai, a 1920s-era tenement known as the Blue House is being renovated and adapted into a mix of independent retail, cultural facilities and subsidized housing.

Many of the original inhabitants will remain, thanks
to lobbying from conservationists and architects,
who convinced the government, which owns the
property, to do something out of the ordinary. Many
of Hong Kong's heritage conservation projects buff
and shine old buildings until they are as refined as a
polished jewel, like the Victorian-era Marine Police
Headquarters, whose forested grounds were exca-
vated for a shopping mall, and whose century-old
patina was scrubbed away to accommodate a luxury
hotel. Buildings like this are still recognizable by
sight, but as far as the other senses are concerned,
they are dead. The Blue House is an attempt to do
things differently. By keeping the building's domes-
ticity alive, and adding new activities like film
screenings in the courtyard, it maintains a more tan-
gible connection to the past, when residents played
their radios, lit incense in the hallways, and hung
their laundry out to dry.

Not far away, in a heavily forested gully filled
with birds and fruit bats—yet surrounded improbably
by office and apartment towers—architects Tod
Williams and Billie Tsien converted a nineteenth-
century British military explosives compound into a
cultural center. The military site had been off-limits
to the public since its inception in 1842; in the 1970s,
most of it had been sold off and redeveloped into
hotels, offices, apartments and shopping malls. Today,
on a road across from the Conrad Hotel and the
British consulate, the Asia Society Hong Kong Center
announces itself with a sleek modern reception hall
that protrudes from a lush hillside. Near the entrance,
an artificial waterfall complements the rush of water
through a stream below. An elbow-shaped bridge
spans the waterway, encouraging visitors to linger
in the humidity of the forest, immersing themselves

in the scent of tree flowers and wet stone and the sound of birdsong. The path underfoot is interrupted by a set of train tracks that once transported explosives around the site. In the new buildings, smooth marble serves as a counterpoint to the gritty texture of the nineteenth-century structures.

When I spoke to Williams and Tsien, they told me they wanted to create a space that served as a counterpoint to the sleek towers around it, with their uniformly buffed surfaces and perfumed lobbies. "We absolutely want people to touch our buildings," said Tsien. "We don't see them as objects to be photographed, we see them as places to be inhabited where they rub off on you and you rub off on them." Most of Hong Kong's sensory depth comes from layers of urbanity and the clash of unlikely neighbors: a corporate office tower that abuts a street market, for instance. The Asia Society's design is unusual because it proactively engages with its context not just visually but in a way that evokes the rest of the senses.

Touch isn't just running your fingers along the side of a wall. It's the feel of the dry autumn breeze after a long muggy summer. It's the experience of weaving between the stalls of a street market. Close your eyes and you can feel the tightness of the space, as a butcher's knife thuds rhythmically and live fish writhe in buckets of salt water, which spills out and soaks the pavement beneath your feet. Sensations are heightened in a high-density city like Hong Kong, where streets are crowded with people and objects, and buildings are so tall and so closely packed that they stifle air flow in the streets, making a gust of wind feel all the more refreshing.

Some of Hong Kong's most recent development schemes tend to overlook the richness afforded by the city's density of people and activities. In fact,

attempts to systematize large areas of the city have often engendered a new variety of disorientation, one that suppresses the senses so crucial to navigating its terrain. One of the most confusing places in Hong Kong is Union Square, a vast, podium-tower complex that includes train and bus stations and a huge shopping mall that burrows beneath sixteen skyscrapers. The mall, Elements, is divided into distinct zones—Earth, Water, and Fire—designed to assist with navigation. Except for this relatively simple visual system of organizing space, most of the mall smells, sounds, and feels the same throughout, rendering visitors helplessly dependent on visual cues.

It's this kind of disorientation that must be confronted and challenged. Hong Kong is a place where we can begin to dismantle the hegemony of vision, thanks to the rich sensory environment created by its unique combination of hilly topography and extreme density. But it is also a place that is particularly vulnerable to late-capitalist development that privileges visual order and threatens sensory heritage; the non-visual means with which its residents instinctively situate themselves are being unthinkingly eradicated by new development that seems to have no tolerance for the mish-mash of uses that has always characterized Hong Kong.

Luckily, for all the Elements that have been built in recent years, Hong Kong is resilient. The very qualities that make it sensorily robust—the density, the hills, the laissez-faire approach to development—ensure it will always retain the messy crust of activity that makes it so confusing, intense and exciting. Architecture that embraces this, like the Blue House and the Asia Society, points the way to how new development can embrace and even enhance Hong Kong. But we can go even further:

why not incorporate a kind of sensory assessment into the development process? The city can only be understood if it is fleshed out and revealed in its whole—not just in the dimensions of its space or in the appearance of its materials, but in the sound, smell and feeling of its living essence.

LAWRENCE WEINER

AN OBJECT MADE TO RESEMBLE ANOTHER BY THE ADDITION
OF A SUFFICIENT QUANTITY OF EXTERNAL QUALITIES

Public installation, Stedelijk Museum, Amsterdam, 1988/1989

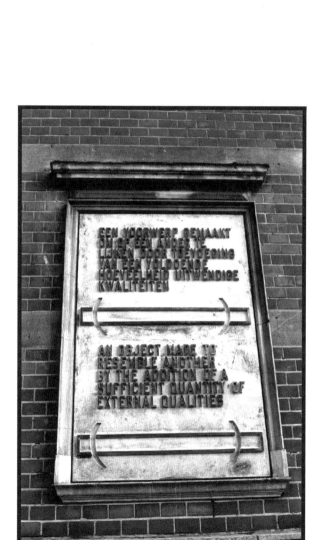

The Future of Public Art in Five Phases

Ben Davis

In order to arrive at a credible predication about the prospects for public art, it is necessary to sketch the past and present of the field, drawing a line through the two toward a possible future.

In the United States, the case for funding public art has always been about the larger questions that surround the idea of value and of the public good. The continuous, uneasy shifting of public art rhetoric can consequently be seen as one where a recurrent artistic dialectic is played out in its most monumental form: aesthetics have been drafted into service to respond to various economic-political conflicts, yet also continuously find themselves at the mercy of economic-political shifts that they are not in control of.

Let's look at how this has played out in the recent past:

PHASE 1: Idealism to Malaise
While there is a history of monument building and public sculpture of various kinds in the United States, it is customary to date the emergence of "public art" as a field to the 1960s. A number of factors formed the particular ideological shape it would take.

1 Attitudes toward art and architecture were shifting in the United States, which, as a rich and powerful nation, had a new sense of creative leadership. With the *Guiding Principals for Federal Architecture* written in 1962 by Daniel Patrick Moynihan, Kennedy would "abolish the 'old-boy' system of federal commissions that had presumed a Beaux Arts style and had relegated sculpture and mural painting to second-class status of ornaments."[1]

2 The Cold War rivalry between the US and the Soviet Union led to a perceived need to earn credibility with intellectuals and project a public image for the United States that cut against its image as "a nation of money-grubbing materialists."[2]

3 The liberal belief in the interventionist power of government to correct social ills was at its height. The National Endowment for the Arts was created by President Johnson in 1965 as of a piece with the Great Society.

4 The top-down "urban redevelopment" initiatives of the 1950s led to a backlash. Jane Jacob's *The Death and Life of Great American Cities* came out in 1961, arguing for increased attention to street-level vitality.

Throughout the 1960s, city governments passed Percent-for-Art laws, mandating that a portion of new construction budgets be earmarked for commissions of public sculpture. Chicago's installation of a monumental Picasso in 1967 is seen to mark the beginning of a vogue for large-scale modernist sculpture.[3] Two years later, the NEA sponsored its first public art commission, Alexander Calder's *La Grande Vitesse*, as the centerpiece of an "urban renewal" initiative in Grand Rapids, Michigan.

It may come as a surprise that Richard Nixon remains the president who did the most to boost the NEA. In 1971, announcing that he was doubling the agency's budget, he declared: "It is my urgent desire that the growing partnership between Government and the arts continue to be developed to the benefit

of both—and that this will be good for the arts and good for the country."[4]

Notably, this Nixon directive came mere weeks after the dramatic 1971 May Day antiwar protests, organized under the slogan, "If They Won't Stop the War, We'll Stop the Government." Protesters tried to occupy plazas, parks, and government buildings in Washington, DC; the state replied by mobilizing some 10,000 troops. The result was the largest single day of arrests in US history.

Such contestation over public space formed the background of Nixon's unexpectedly high-flown artistic rhetoric. Yet in truth, a backlash against the idealism and perceived elitism of public art's official version had already begun to set in.

Under Nixon, the NEA would, for the first time, officially define criteria of "site-specificity" in public sculpture. Yet this was itself a response to a percolating sense that all was not right. Already at the end of the 1960s, architect James Wines (of the firm SITE) formulated the concept of "plop art" to describe the abstract, isolated trophies that had begun to infest the urban landscape.[5]

At the same time, the long postwar economic boom in the United States waned in the 1970s. The vicious, stagflationary decade would further undermine the idea of an optimistic, forward-marching modernism. As Casey Nelson Blake, editor of *The Arts of Democracy: Art, Public Culture, and the State*, has summarized: "[I]n many ways, by the mid-to-late 1970's public art installations no longer seem like these vehicles of urban revitalization, but rather seem like the most visible symbols of a liberal urban project that had gone terribly wrong."[6]

PHASE 2: Backlash

The term "postmodernism" arrived on the scene in 1979. It was coined by French thinker Jean-François Lyotard to describe the waning of a belief in "master narratives." These included the optimistic teleologies of modernist art,[7] but also the idea that governments might intervene successfully in the economy.[8] This mood could not help but affect the surrounding prospects for public art.

It has become a cliché to explain every malignant feature of the ensuing decades as the result of "neoliberalism," the program of pro-market, anti-government initiatives symbolized by the ascent of Ronald Reagan to the presidency in the United States. William Davies' recent proposal of a more fine-grained periodization of the term is worth bringing in here.[9] Davies sees its first phase, what he calls "Combative Neoliberalism," as lasting from 1979 to 1989.

Against the background of the febrile final decade of the Cold War and the labor and social movements of the recent past, "Combative Neoliberalism" was accompanied by the need to militantly assert its ideology via a program of demonizing perceived enemies. Public support of art provided a convenient face for wasteful government, with Reagan igniting the so-called culture wars as a unifying device.

In public art, the most iconic confrontation of the decade would be over Richard Serra's *Tilted Arc*, a curving, 120-foot-long metal sculpture installed in Federal Plaza in downtown New York in 1981, and finally dismantled in 1989. The work was defended by museum directors and art critics using the language of site-specificity and avant-garde provocation. It was disliked by city bureaucrats and office workers at the site, who

found the vast steel wall to be an obstruction of a once open space.

This profile did not exactly make *Tilted Arc* the ideal poster child to generate widespread sympathy for public art funding. Accounts of the contretemps make it clear, however, that for defenders, criticisms of *Tilted Arc* as ugly and obstructing were seen by liberal arts advocates as of a piece with the "authoritarian populism" of Reagan, with its appeal to simple, sentimental values.[10]

Yet, if demonizing the government was one pillar of Combative Neoliberalism, reconstructing the social terrain to the benefit of private capital was the other. Thus, Rosalyn Deutsche argues in her famous essay about the Serra affair:

> The decision against *Tilted Arc* was not a ruling against public art in general. On the contrary, the verdict coincided and was perfectly consistent with a widespread movement by city governments, real-estate developers, and corporations to promote public art, especially something called the "new public art," which was celebrated precisely because of its "usefulness." The new public art was defined as art that takes the form of functional objects placed in urban spaces–plumbing, park benches, picnic tables–or as art that helps design urban spaces themselves. Official efforts to discredit *Tilted Arc* cannot be isolated from attempts to portray other kinds of public art as truly public and useful. Moreover, the promotion of the new public art itself took place within a broader context, accompanying a massive transformation in the uses of urban space–the redevelopment and gentrification engineered throughout the 1980s

as the local component of global spatioeco-
nomic restructuring. The *Tilted Arc* proceedings
were, then, part of a rhetoric of publicness and
usefulness that surrounded the redevelopment
of urban space to maximize profit and facilitate
state control. *Tilted Arc*, represented by its oppo-
nents as elitist, useless, even dangerous to the
public, became the standard foil against which
conservative critics and city officials routinely
measure the accessibility, usefulness, humane-
ness, and publicness of the new public art.[11]

The transition Deutsche refers to is sometimes
referred to as the shift from "art-in-public-places" to
"art-as-public-places."[12] The new strain of work justi-
fied itself as environmental design, with artists serving
as part of architectural "design teams"–in essence pro-
viding spruced-up site features, like the curving green
benches and hedges by Martha Schwartz that ulti-
mately replaced Serra's steel barrier in Federal Plaza.

Yet the formal shift is less important than the
larger overarching shift of emphasis: Public art
would be about offering attractive amenities, not
symbolizing higher ideals.

PHASE 3: Blips
Davies dates his second phase, "Normative
Neoliberalism," from the fall of Communism in 1989
to the financial crisis of 2008, describing it as a period
when market logic, no longer having to justify itself
against any rival, now became proposed as the
default logic of society. Under the guise of concepts
like attracting "human capital," economic language
worked its way into all aspects of endeavor, includ-
ing urbanism, with corresponding effects for theories
of public art.

A short list of the new set of factors for arts through this period would be:

1 Art itself became more professionalized, less associated with bohemian or intellectual values, and more associated with an idealized form of luxury consumption.

2 As inequality increased, catering to the tastes of the top-earners became more economically important, with cultural amenities viewed as a valuable way to lure the wealthy.

3 As manufacturing migrated offshore or faced waning fortunes, conventional wisdom held that the "creative economy" (services, high-tech, etc.) was the key to First World economic success, making public art a valuable branding symbol of creative dynamism.[13]

4 Global integration increased tourism in general, again making cultural tourism that catered to the newly robust middle classes of developing nations and the jet-setting winners of the New Economy in the developed world a larger and larger part of economic activity in general.

One of the showpiece cases of this philosophy at work in the United States was New York City under the leadership of financial services billionaire Michael Bloomberg (2001–14), who came to power as Richard Florida's development handbook, *The Rise of the Creative Class* (2002), was becoming gospel among city bureaucrats.

Boasting that he would apply "private sector" logic to government in a much-cited 2003 speech,

Bloomberg argued that, given the reality of global urban competition for businesses, New York would need to sell itself as a "luxury product."[14]

It's not a coincidence that Bloomberg's mayorship would shortly be dubbed the "Arts Administration," having done "more to promote and support the arts than any in a generation," according to the *New York Times*. "Under Mr. Bloomberg, public art has flourished in every corner of the city."[15] This artistic feat was the aesthetic sideshow to a development tsunami that saw a rezoning of thirty-seven percent of the city.

While this metamorphosis involved plenty of new-model "plop art" to brand various luxury apartments, a notable feature has been the increasing number of what you could call "blip art": works monumental in scale but temporary in nature.

New York's public parks have shown programs of temporary sculpture since 1967, but the escalating program of showy temporary interventions, from Jeanne-Claude and Christo's *The Gates* (2005) to Olafur Eliasson's *New York City Waterfalls* (2008), was unprecedented. Even the somber *Tribute in Light*, the famous, and now annually recurring, monument to the fallen Twin Towers, originally conceived by Municipal Art Society and Creative Time, can be said to fit in this model.

Indeed, this increasing weight given to temporary public art over lasting symbols of place under Bloomberg might be said to fit nicely with the evolving theory of "luxury goods" themselves, no longer pitched as representing durable timeless craftsmanship, but up-to-the-minute branding.[16]

Increasing inequality has been the economic trend since the 1980s, with its correlate in the successful New Economy city being bitter battles over

gentrification experienced as cultural change. Rather than providing symbols of civic togetherness, this latest wave of public art appears more as a way to give a sheen of public benefit to development meant to favor the very rich.

A key example might be Kara Walker's 2014 *A Subtlety* (aka the "sugar sphinx"), sponsored by Creative Time in partnership with Two Trees Management as an amuse bouche for an impending luxury redevelopment of the Williamsburg waterfront in the Domino Sugar Factory, a potent symbol of New York's receding blue-collar past.

PHASE 4: Bifurcation

The final phase of Davies' neoliberal typology flows from the fallout of financial crisis of 2008. He terms this the era of "Punitive Neoliberalism," in which the logic of treating society according to business terms persists, even though the dysfunctional side of this logic has become so visible that it no longer seems to make rational sense.

Between 1940 and 1980, the economic geographic story in the US was one of regional economic convergence. But "starting in the early 1980s, the long trend toward regional equality abruptly switched." Globalization and corporate consolidation meant that "a few elite cities have surged ahead of the rest of the country in their wealth and income," leaving stagnation elsewhere.[17]

Despite the gentrification that has made New York one of the most unaffordable places to live, it represents the winning side of the equation. Since the turn of the millennium, the Big Apple sucked in an increasing share of the United States new Creative Economy jobs.[18]

The metropolis also used its position as cultural hub to spectacularly absorb larger and larger percentages of tourism flows. "In this recession, the country lost 6 percent of private-sector jobs and got about a quarter back," Bloomberg said in 2011. "New York City lost 0.3 percent and got them all back. Why? Because we have the option to use tourism to replace growth."[19]

What does this mean, however, for the languishing rest of the country? The signature public arts theory of recent years is "creative placemaking," formulated for the NEA in a 2010 white paper by Ann Markusen and Anne Gadwa, then adopted across the country with "unprecedented speed and coordination."[20]

In their introduction, the authors make clear the economic prognosis undergirding their vision:

> For two decades, American cities, suburbs, and small towns have struggled with structural change and residential uprooting. The causes are powerful: an integrating world economy, accelerating technological change, and Americans' proclivity to move. These forces unsettle communities and diminish returns on past investments in public infrastructure and in local networks and know-how.[21]

Postulating that attempts to retain employers are futile, they then offer the arts as a solution:

> Yet revitalization has come from an unexpected quarter. Mostly under the radar, unusual partners have made significant arts and cultural investments, leveraging resources from many funding sources. They create and provide jobs,

nurture local businesses, generate spin-offs, revitalize local economies, and stabilize neighborhoods. They reinforce the nation's global leadership in cultural industries, a major source of jobs.[22]

In terms of strategy, "creative placemaking" is substantially eclectic (it is "asset-based," in the lingo, looking to activate local resources first of all). It touts initiatives from Providence, Rhode Island's WaterFire festival of urban bonfires along the city's three rivers, to Paducah, Kentucky's Artist Relocation Program, which lured artists to a blighted historic neighborhood with the promise of property ownership.

Observers note that "creative placemaking" draws on earlier theories of the "creative class" and "creative economy." Yet, while it is far from consistent on this score, what appears distinctive about the new rhetoric is the degree to which it suggests using art not to *attract* or *retain* desirable residents or employers, but to *replace* industry via small-scale, local cultural initiatives.

Thus, "creative placemaking" booster Leonardo Vazquez will acknowledge that "attracting a large employer would have a bigger immediate impact than many arts initiatives."[23] However, arts-focused development appears to him the more realistic option, given the straightened times:

With the exception of large performing arts spaces, very little space has to be created or reallocated for creative uses. In most cases, creative activities can reuse space at little direct cost to communities. There are no educational requirements to be a producer of creative products. The manufacturing of creative products, which can

be done in small facilities, does not often require higher education. While creativity and technical skill are barriers for designing creative products, much of the work of transporting and managing creative products, as well as supporting the operations of creative economy enterprises, can be done without a great deal of these skills. Many creative activities tend to be more labor-intensive than capital-intensive, so the financial barriers to entry are lower than for other types of industry.[24]

The formulation is extraordinary: rather than the figure of an alien cosmopolitanism, or a highly refined branding operation, art is enlisted as a replacement for blue-collar labor!

One notable feature of the post-2008 world was that economic austerity policies, once sadistically directed at Third World countries as part of their debt crises, came to be applied to the economies of the debt-ridden First World itself. It may be worth noting, then, that cultivating local tourist attractions, packaging local traditions, and selling handicrafts has long been the preferred development advice for Third World countries that lack industries competitive with more sophisticated foreign rivals.

In that sense, the near simultaneous turn of small towns and Rust Belt cities across the United States toward rebranding themselves as artsy destinations may, at some future date, be looked at as yet another symptom of the period of Punitive Neoliberalism.

PHASE 5: The Future of Public Art

If economic growth continues to be captured by the wealthiest layer of society, then the cities or regions that will continue to grow will be the ones that manage to transform themselves to cater to this layer. Yet because the spoils of this economy are so unevenly shared, and concentrated in a minority, growth must almost by definition be uneven and experienced by a minority of locations. It *cannot* be that metropolitan hubs like New York will suck up larger quantities of this attention at the *same time* that second- and third-tier cities all simultaneously transform themselves into vital sites of cultural tourism.

Thus, already, Markusen[25] and Gadwa[26] have both distanced themselves from the promises of their original paper. Other observers have stressed that "creative placemaking" initiatives function as part of a complex web of economic and governmental forces, and can only be held accountable for the very limited types of good that those small-scale public art projects can bring.[27]

The clearest thinking about the subject comes from Mark Stern. Looking at the city of Philadelphia specifically, Stern mapped both poor and better-off neighborhoods that featured concentrations of cultural resources, and was even able to demonstrate the real benefits generated in terms of improved measures of communal well-being.

Yet, despite this, Stern noted that measured over time, "cultural resources in the city are increasingly clustered in the better-off neighborhoods," particularly as a result of "a decline in cultural assets in Philadelphia's low-income communities."[28] Put bluntly: organizations in poorer, largely African American communities found it harder to sustain

the level of cultural investment required to realize
the promises of "creative placemaking."

Stern sees this, finally, as a problem stemming
from the limits of public art funding as urban
policy itself:

> Ultimately, creative placemaking initiatives
> are about making grants to organizations.
> Even when these initiatives require collabora-
> tions between multiple partners, they are
> likely to include only a fraction of the "cultural
> assets" in a particular neighborhood. The gap
> between culture's impacts–based on the aggre-
> gate efforts of dozens of different organizations,
> informal groups, and individuals–and funding
> mechanisms–which identify specific organiza-
> tions–will continue to pose a challenge to those
> who wish to link creative placemaking to a
> specific set of social benefits.[29]

It is almost as if, when thought through rigorously,
the question of "creative placemaking" pushes it
up against the limits of its original frame as a
strategy of leveraging modest investments in culture
in the absence of economic growth. Realizing the
promises of public art leads us back to the need
for large-scale investment, and the economic
redistribution between people and regions that
this would entail.

Without more evenly distributed growth, what-
ever the fate of many individual worthy projects, the
overall future of public art looks bipolar–because
history has shown that public art's meaning and
prospects are always overdetermined by the tensions
of the society that produces it, and our society has
become wildly economically bipolar.

At one extreme, public art will likely be symbol of the city as luxury commodity. At the other, it will be testimony to inadequate and under-resourced government policy. Or society itself will become more equal, and in the process create a new symbolism.

1 John Wetenhall, "A Brief History of Percent-for-Art in America," Public Art Review (Volume 5, Number 1), https://umedia.lib.umn. edu/node/469107 "https://www.gsa.gov/portal/content/136543. Accessed on October 9, 2017.

2 Arthur Schlesinger, Jr., quoted in Lewis Hyde, *The Gift: Creativity and the Artist in the Modern World* (Vintage, 2007), 374.

3 Harriet F. Senie, "Baboons, Pet Rocks, and Bomb Threats: Public Art and Public Perception," *Critical Issues in Public Art: Content, Context, and Controversy* (Smithsonian Books, 1998), 237.

4 Richard Nixon, "Memorandum About the Federal Government and the Arts" http://www.presidency.ucsb.edu/ws/?pid=3026. Accessed on October 9, 2017.

5 James Wines, interviewed by Alyssum Skjeie, "James Wines: The Architect Who Turned Buildings Into Art," http://blog.cmoa. org/2015/07/james-wines-the-architect-who-turned-buildings-into-art/. Accessed on October 9, 2017.

6 Casey Blake, quoted in John Emerson, "Whose Streets?," Social Design Notes http://backspace.com/notes/2004/02/whose-streets.php. Accessed on October 9, 2017.

7 It is at this same moment that the NEA opened up its patronage beyond formalist modernist sculpture: "By the end of the 1970s, the NEA endorsed a 'wide range of possibilities for art in public situations'—'any permanent media, including earthworks, environmental art, and non-traditional media, such as artificial lighting.'" Miwon Kwon, "Sitings in Public Art: Integration versus intervention," *One Place After Another: Site Specificity and Locational Identity* (The MIT Press, 2004), 67.

8 See Jean-Francois Lyotard, *The Postmodern Condition: A Report on Knowledge* (University of Minnesota Press, 1984), 5.

9 William Davies, "The New Neoliberalism," *New Left Review* 101 (Sept.–Oct. 2016), https://newleftreview.org/II/101/william-davies-the-new-neoliberalism. Accessed on October 9, 2017.

10 Rosalyn Deutsche, "*Tilted Arc* and the Uses of Democracy," *Evictions: Art and Spatial Politics* (The MIT Press, 1998), 266.

11 Ibid., 259.

12 Kwon, 60.

13 Elena Lombardo describes four main "art-based local development trends," all of which are currently active: the "art-based tourism" model, dating from the 1960s; the "creative class" model of revitalization through attracting artistic communities, arising from the 1980s; the "creative sector" approach of focusing on cultural industries, dating from the 1990s; and, finally, "creative placemaking," from the 2010s. "Art-Based Local Development: Strategies, Opportunities, and Challenges." *The Role of Artists and the Arts in Creative Placemaking*, 19–22. http://www.goethe.de/ins/us/was/pro/creative_placemaking/2014_Symposium_Report.pdf. Accessed on October 9, 2017.

14 Michael Bloomberg, quoted in Diane Cardwell, "Mayor Says New York Is Worth the Cost," *New York Times* http://www.nytimes.com/2003/01/08/nyregion/mayor-says-new-york-is-worth-the-cost.html. Accessed on October 9, 2017.

15 Jennifer Steinhauer, "The Arts Administration," *The New York Times* http://www.nytimes.com/2005/10/23/arts/the-arts-administration.html. Accessed on October 9, 2017.

16 As Bernard Arnault expressed it: "You feel as if you must buy it, or else you won't be in the moment. You will be left behind." Bernard Arnault, quoted in Heather Thomas, *Deluxe: How Luxury Lost Its Luster* (Penguin Books, 2008), 41–42.

17 Phillip Longman, "Bloom and Bust," *Washington Monthly* (Nov.-Dec. 2015) http://washingtonmonthly.com/magazine/novdec-2015/bloom-and-bust/. Accessed on October 9, 2017.

18 "In 2003, 7.1 percent of the national creative workforce was centered in the Big Apple. By 2013, that share had grown to 8.6 percent, far higher than the city's 3 percent share of all jobs in the nation." Adam Forman, *Creative New York 2015*, https://nycfuture.org/pdf/Creative-New-York-2015.pdf. Accessed on October 9, 2017.

19 Micahel Idov, "And Another Fifty Million People Just Got Off of the Plane," http://nymag.com/news/features/tourism/tourist-increase-2011-12/. Accessed on October 9, 2017.

20 Nicodemus, quoted in Lombardo, 20 (see note 13).

21 Ann Markusen and Anne Gadwa, *Creative Placemaking*, 3. https://www.arts.gov/sites/default/files/CreativePlacemaking-Paper.pdf. Accessed on October 8, 2017.

22 Ibid.

23 Leonardo Vazquez, "Creative Placemaking: Integrating community, cultural and economic development," http://togethernorthjersey.com/wp-content/uploads/2014/06/Creative-placemaking-integrating-CCED.pdf, 9. Accessed on October 9, 2017.

24 Ibid., 12.

25 Ann Markusen, "Fuzzy Concepts, Proxy Data: Why Indicators Won't Track Creative Placemaking Success," http://createquity.com/2012/11/fuzzy-concepts-proxy-data-why-indicators-wont-track-creative-placemaking-success/. Accessed on October 9, 2017.

26 Nicodemus (see note 20).

27 Ian David Moss, "Creative Placemaking Has an Outcomes Problem," http://createquity.com/2012/05/creative-placemaking-has-an-outcomes-problem/. Accessed on October 8, 2017.

28 Mark J. Stern, "Measuring the Outcomes of Creative Placemaking," *The Role of Artists and the Arts in Creative Placemaking*, 92. http://www.goethe.de/ins/us/was/pro/creative_placemaking/2014_Symposium_Report.pdf. Accessed on October 8, 2017.

29 Ibid., 94.

LAWRENCE WEINER

A TRANSLATION FROM ONE LANGUAGE TO ANOTHER

Public installation, Het Spui, Amsterdam, 1996

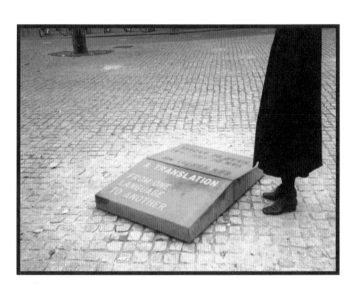

The Public in Outer Space

Sarah Fecht

When Neil Armstrong and Buzz Aldrin touched down on the moon in 1969, they arrived in a craft roughly the size of a two-person tent. The landing module had no recognizable toilet and no privacy, but it didn't matter much, since the men were only making a day trip. Humanity is now, once again, trying to crack out of the shell of its atmosphere, but the goal has changed: we want to go to the Moon and to Mars, not just to plant a flag and leave behind a few footprints, but to stay.

For some, the reason to settle on Mars is evident in the challenges and the opportunities it presents. Crossing vast oceans, climbing the highest mountains, and visiting the most extreme environments can inspire generations and lead to unforeseen scientific and economic discoveries. Traveling to Mars and installing a new foothold for humanity could push the limits of technology, the human psyche, and design, and potentially teach us how to live better on Earth.

Inhabiting off-planet space offers the chance to experiment with new social and environmental arrangements that incorporate lessons we've learned from mistakes on Earth. "If you want to go to Mars, let's live, and live happily, and live better than here on Earth," says Vera Mulyani, an architect and founder of the Mars City Design competition. "Let's design a better place for humanity." Justin Hollander, a Tufts University professor of urban planning and advisor for Mars One—an organization that aims to set up a permanent Mars settlement by 2035—likewise suggests that a blank slate provides a chance to privilege elements of good urbanism, such as public space, rather than adding them as an afterthought. The challenges of lethal surroundings and the freedom of lower gravity will no doubt rewrite some

of the rules of design. But by redefining how we interact with nature and with ourselves, space colonization offers a broader chance to remake urbanism itself, and by extension, public spaces and the publics who use them—the implications of which could play out both on Mars, and on our own ecologically changing planet.

It may come as no surprise that there are some who don't think we should colonize other worlds. Although Elon Musk believes we must establish a colony on Mars in order to ensure the future of humanity in case of an asteroid strike or climate-related cataclysms, there's no guarantee that humans can even survive long-term on Mars. The low gravity will weaken our bones, hearts, and immune systems. The soil is toxic, the air unbreathable. Can humans have babies in microgravity? No one knows. And every rocketful of supplies we launch to Mars will cost hundreds of millions of dollars. For context, it took $150 billion to build the International Space Station that orbits Earth, and that's right in our cosmic backyard. Many people think the colonization money would be better spent trying to save the planet we have.

These physiological and economic barriers aside, colonization of other planets would entail other trials. "[L]iving far away from Earth in confined, artificial environments will challenge psychological health in brand new ways," writes space architect Brent Sherwood in his book, *Out of This World: The New Field of Space Architecture*. That's why, if we choose to accept the serious challenges and risks that come with off-world living, it's important for architects and designers to start thinking about how to make spaceships and habitats not just survivable, but actually livable. Future astronauts will

need public places to rest, socialize, and congregate, in order to maintain healthy minds and a healthy society—and public (as well as private) spaces will play a role in working towards a functioning Martian society, and even perhaps, one day, the ideal of a Martian utopia.

But utopia won't happen immediately (if ever). For now, Earth's best and brightest are still working out how to fulfill our basic needs in space, like oxygen, water, and food.

The first travelers to Mars will likely set sail in groups of four, traveling inside large metal cans linked together, with solar panels extending out like sails. Each ship will be about the size of a small two-bedroom house, which almost seems roomy until you consider all the supplies and science equipment they'll need to haul for the years-long mission. In working toward the ideal of a Martian utopia, "We have got to figure out how to build these things to keep people happy, productive members of society for years at a time," says Tristan Bassingthwaighte, an architectural designer at Deep Space Ecology. "If your whole crew goes insane, it's still just as much a mission failure as if you crash into Mars."

We don't know how human culture, technology, and eventually even biology will change once we leave Earth, but we can anticipate some of the design essentials for the initial missions.

The first habitats on Mars or the Moon will likely be similar to those four-person spaceships: small and cramped, with social life centered around the kitchen table. For long-term stays, these pill- or dome-shaped aluminum cans and inflatable structures would need to be covered with a thick layer of rock and dirt to protect the crew from deep space radiation as well as extreme temperature shifts.

During these early years of interplanetary exploration, private space may be just as much a concern as public space. Starting in August 2015, Bassingthwaighte and five others spent twelve months cooped up in a simulated Martian habitat in Hawaii called HI-SEAS. The habitat was designed to be as open as possible to combat the quasi-astronauts' sense of confinement, but as a result, nearly every part of the habitat was visible or audible from everywhere else. "We actually didn't have nearly enough private space," says Bassingthwaighte. "It was one of the bigger stressors after a while. It's very hard to get into a place where you can unwind and let down that last psychological wall…. That constant stress will definitely contribute to aggravations or misunderstandings."

An architecture student at the time, Bassingthwaighte wrote his doctoral dissertation on how he would improve the design of this mock Mars habitat. He suggests keeping the large open common room, but making it convertible into smaller, more private spaces, so that the area could be used for events like soccer practice and movie night, or provide private areas for people to draw or read (or perhaps write their 305-page dissertations). Since permanent residences on Mars will need to be buried beneath several feet of soil, Bassingthwaighte would use virtual reality to help people escape that closed-in feeling, and a CoeLux artificial skylight that "perfectly replicates the look and feel of natural sunlight. It tricks your mind into thinking there's a much larger space just on the other side of the [simulated] glass."

Looking decades or even centuries into the future, the Musk-founded Space Exploration Technologies Corporation–popularly known as

SpaceX—hopes to send colonists to Mars in droves. The company hasn't unveiled details about the innards of its mega-sized colonial ship concept, other than a sleek white interior with large windows, but the 100-person spaceship Musk envisions would obviously need large gathering spaces. Like soldiers on military aircraft carriers (known as "cities at sea"), these Martian colonists would probably pass the time socializing in common areas such as a gym or cafeteria.

Yet Hollander thinks these sorts of sleek white "futuristic" spaceship interiors, depicted everywhere from *2001: A Space Odyssey* to *The Martian*, are too sterile for a years-long journey. "Everything looks like it's made by machines," he says. "There's no details, nothing intricate, even though that's what we really want." Some concepts include natural materials like wood veneer and woven fabrics, "to create a greater feeling of home and, since monotony is a potential psychological issue, for visual and tactile stimulation."

As the Mars bases grow and humanity establishes a more permanent off-world settlement, public gathering spaces will likely become more important. Crusan speculates that these crews may live in independent habitat modules, landed across multiple missions and amassed into one general area, similar to a trailer park. Newer buildings would be constructed from glass or concrete made on Mars. This homegrown masonry and 3D printing would allow for the creation of larger gathering spaces that could bring together the growing Mars population under one roof to maintain a sense of community, and to make decisions that affect the entire group. These areas will no doubt be the gathering spaces where the foundations of Martian civilization are laid. And if these far-flung societies can become stable and

self-sufficient, they will surely attract other explorers, entrepreneurs, and free-thinkers over time.

Such a population explosion on Mars might present its own challenges to the utopian ideal, or at the very least force us to ask exactly what sort of Martian utopia we are seeking. According to the Outer Space Treaty, drafted in 1966 and accepted by the United Nations a year later, all of outer space is a public space—or rather, something like a public good, not to be subject to "appropriation by claim of sovereignty, by means of use or occupation, or by any other means." Yet in so many proposed space colonization scenarios, spearheaded by both public space programs and private companies such as SpaceX, other worlds are also invariably viewed as potential sites of economic opportunity, largely by way of extraterrestrial resource extraction. As our economies migrate with us to other worlds, how will our structures of ownership translate to these alien landscapes?

Perhaps before reaching Mars, a settlement on Earth's moon could more quickly and easily grow into an economic center, thanks to its proximity. Using essentially the same infrastructure as a Mars base, these lunar colonies would likely start out as research outposts that grow into industrial towns mining for helium-3, an isotope that could fuel fusion reactors, and water, which can be broken down into hydrogen and oxygen, aka rocket propellant. People like the European Space Agency's Johann-Dietrich Woerner and George Nield from the US Federal Aviation Administration envision these bases growing into an off-world marketplace, perhaps transforming the moon into a bustling gas depot where Mars-bound spaceships could top off their tanks before the long journey ahead.

If the lunar industries really do take off, the people working there, and their families, will need apartments, offices, farms, and assembly halls to form a functional society. Sherwood thinks those amenities could pave the way for lunar tourists, which in turn could lead to more development, including theaters, pools, restaurants, hotels, bars, and arenas for playing low-gravity sports.

Some folks even want to establish parks on the moon to protect historical areas like the Apollo 11 landing site. While the views from these outdoor spaces will no doubt be incredible, they could only be enjoyed from inside a spacesuit, cut off from your companions except by the radio in your helmet. Nevertheless, by the standards established in the Outer Space Treaty, such "supranational parks" may best represent the lofty ideal of outer space as shared treasure, to be enjoyed by all of humanity. The management of such culturally significant areas might serve as a mirror, or perhaps even a model, for preservation and conservation efforts on Earth—particularly as terrestrial public lands are increasingly threatened by privatization.

Though there will be plenty of open areas on Mars, the real, every day off-world public spaces will be indoors, and for the foreseeable future they won't be as grand as one might hope. "When it comes to large structures and domed cities, I don't believe that will be in my lifetime," says Crusan. Sadly, those majestic glass-domed cities we see in sci-fi drawings of lunar settlements would actually bake people alive, Sherwood notes, since the moon's surface can reach nearly 250 degrees Fahrenheit. A domed city might not be quite so hellish on Mars, whose daytime temperatures max out at about seventy degrees, but the glass still wouldn't offer much protection against

radiation. And unfortunately for humanity, terraforming would probably require thousands of years to make the Martian air breathable for humans.

While Martians will need greenhouses to grow their food, neither recreational indoor parks nor installing greenery in the public spaces would be practical in Mars habitats for a while—it would be too difficult to regulate the moisture and oxygen levels in those areas. But there are other ways to make a space feel natural. Bassingthwaighte recommends locating the greenhouses next to the gathering space, separated by clear glass. That way, the food crops would be visible from the public space, replicating the relaxed stimulation that nature can provide, while maintaining the ideal air quality in each separate space. Hollander suggests designing with fractal patterns, curves, interesting textures, the color green, and maybe even piping in the sounds and smells of Terran nature.

Though these indoor public spaces will be largely unlike any domicile our species has built before, Sherwood recommends looking to history for inspiration. Roman outdoor spaces were essentially enclosed "rooms" for public rituals, proving that interior urbanism "can nonetheless be grand and theatrical and promote civic life." Medieval and Gothic architecture, he notes, show that "we can use precious but dangerous external views sparingly, yet still be emotionally and spiritually inspiring." Islamic courtyards bring nature into the center of the home, and modern-day shopping malls provide an airy indoor space for entertainment, exercise, and socializing.

Such earthly design inspirations offer many practical points of departure, and their variety of forms beg us to speculate on the nature of public life in outer space. The interior urbanisms of

ancient Rome or a modern-day shopping mall, after all, reflect very different types of publics. To what degrees will the space-faring public be determined by citizenship or consumerism, traditional family structures or extended kin, interdependence with, or independence from outside forces (a faraway Earth, for instance)? If Mars is a blank slate, it is one upon which space architects and designers are apt to project their own interpretations of (or assumptions about) these issues. The colonists themselves are also likely to hold a variety of attitudes towards these questions, some of which may agree or conflict with one another. The built environment of lunar or Martian colonies, even at the most intimate scale, will comprise spaces for negotiating both survival and society, and its physical design will affect the parameters of that negotiation, opening doors to some possibilities while closing others. Respecting the complexity of this relationship may be a crucial, if often overlooked, component of both public and private visions of space travel or colonization, particularly as the momentum to expand into deep space keeps growing.

The European Space Agency dreams of setting up a "moon village" populated by researchers, miners, entrepreneurs, and tourists. NASA intends to go further, in the mid-2030s, by sending astronauts to Mars on a journey that would take two to three years, round-trip. Private companies may beat NASA to the red planet: Mars One aspires to send an initial crew of four intrepid explorers on a one-way mission to establish a permanent settlement. SpaceX hopes to launch a Mars-bound crew as early as the mid-2020s, paving the way for a colony that could grow to house a million people within a few decades– or so Elon Musk hopes.

Regardless of who gets there first, the need for a place to interact away from home or work seems inevitable. Over time, these public spaces may become the seats of local governments, as well as places for marriages, political discussions, carnivals, cinemas, funerals, parties.

As their society grows and becomes self-sufficient, Martians will need to create their own systems for dealing with problems and governing themselves. They'll develop their own traditions, jokes, and idioms. These cultural transformations will most likely have their origins in the shared spaces where everyone comes together.

Eventually, as its culture evolves, one could expect that a colony may even start to feel like its interests and values have diverged significantly from those on Earth. History suggests that eventually, these colonists could decide to declare independence from forms of Terran rule. One could easily imagine that decision being made in a cafeteria or sports arena that doubles, intentionally or not, as an agora; public spaces could be the gardens where the seeds of Martian revolution are planted.

Luckily for Earthlings, off-world innovations, whether cultural or scientific, won't likely be restricted to these future off-world settlements. Learning how to 3D-print a house using local materials, living off renewable energy in zero-waste neighborhoods, and designing cities for inclusivity are ideas that could help humans on any planet, as well as the other lifeforms forced to interact with us.

Perhaps colonizing other worlds would, in fact, help us save the planet we already have. The barren surface of Mars represents the extreme end of processes that humans have unwittingly initiated on Earth: climate change, land degradation, and

desertification. Scientific efforts to solve the problem of habitation on Mars, whether ultimately successful or not, may provide invaluable clues for helping reverse these processes on Earth, or at the very least mitigating their worst effects on human society.

And perhaps the idea of widespread space colonization obliges us to revisit the Outer Space Treaty and its utopian ideals. If the Moon or Mars "shall be the province of all mankind," should Earth be as well? As this question becomes less abstract, how we choose to answer it will be of significant consequence to publics on all planets, and for all of the spaces they share in common.

Partners' Statement

Taking part in shaping a city is a privilege. When a new urban design project begins, we are ordinarily granted the opportunity to start with some form of public engagement. Hundreds of hours are spent listening to the questions, concerns, and aspirations of the residents, business owners, advocates, city planners, and, of course, clients who will be impacted by our design decisions. This book is meant to expand upon—and deepen—that act of listening. By reaching out to writers with a broad spectrum of critical perspectives, we hope to not just inspire new ways of translating positive social values into the material conditions of public spaces, but to remind ourselves that these are the very sites wherein such values are negotiated. Like any good public space, we hope that this book will serve as a forum for an inclusive, productive debate about the future of our shared environment.

About the Contributors

Allison Arieff is Editorial Director for the urban planning and policy think tank, SPUR. A contributing columnist to *The New York Times* for over a decade, Allison writes about architecture, design, and cities for numerous publications including *California Sunday*, the *MIT Technology Review*, *Dialogue*, and *CityLab*. She is a former editor-at-large for *GOOD* and *Sunset* magazines, and from 2006–08 was senior content lead for the global design and innovation firm IDEO. She was editor-in-chief of *Dwell* (and was the magazine's founding senior editor) until 2006, and is author of the books *Prefab* and *Trailer Travel: A Visual History of Mobile America*.

Michelle Nijhuis writes about science and the environment for *National Geographic* and other publications. She is also a longtime contributing editor of *High Country News*, a magazine known for its in-depth coverage of environmental issues in the western US. Her work has won several national awards and been included in four *Best American* anthologies. After fifteen years off the electrical grid in rural Colorado, she and her family now live in White Salmon, Washington.

Jaron Lanier is a computer scientist, composer, visual artist, and author who writes on numerous topics, including high-technology business, the social impact of technological practices, the philosophy of consciousness and information, internet politics, and the future of humanism. His book *Who Owns the Future?* received the Goldsmith Book Prize from Harvard in 2014, and was called the most important book of 2013 by Joe Nocera of the *New York Times*. His 2010 book, *You Are Not a Gadget*, was also named one of the ten best books of the year by the *New York Times*. His writing has appeared in numerous places including *Wired*, where he was a founding contributing editor.

Freelance writer, volunteer firefighter, and occasional radio host Rachel Monroe is based in Marfa, Texas, where she writes about crime, books, border issues, and utopian experiments. She's written for the *New Yorker*, *New York* magazine, the *Oxford American*, *Texas Monthly*, the *Guardian*, and *Bookforum*, among others. She was selected as one of the female journalists everyone should read by *New York*, was a finalist for The Livingston Award for Young Journalists, and featured on Longform's list of the top ten pieces of 2014. Her new book, *A Life in Crimes*, will be published by Scribner in 2019.

China Miéville is the author of many works of fiction—including *The City & the City*, *Three Moments of an Explosion: Stories*, and *This Census-Taker*—and non-fiction, including, *Between Equal Rights* and *October: The Story of the Russian Revolution*. He has won the Hugo, World Fantasy, and Arthur C. Clarke Awards. A founding editor of the quarterly *Salvage*, he lives and works in London.

Christopher DeWolf is the author of *Borrowed Spaces: Life Between the Cracks of Modern Hong Kong,* which explores how Hong Kong's citizens have shaped their city through informal urbanism, despite a rigid government bureaucracy. His interest in cities started with SimCity and eventually expanded into the real world, where he began writing about urban history, architecture, design and culture for publications such as *TIME,* the BBC, the *South China Morning Post,* and the *Wall Street Journal.* He currently lives in Hong Kong in a tiny apartment with a very good view.

Ben Davis is an art critic living and working in New York City. He is the author of *9.5 Theses on Art and Class* and is currently national art critic for *artnet News.* He was an editor of *The Elements of Architecture,* the catalogue of the 2014 Venice Architecture Biennale. His writing has appeared in *The New York Times, New York,* Slate.com, *The Village Voice, The Brooklyn Rail, e-flux Journal,* and others.

Sarah Fecht runs the Earth Institute's *State of the Planet* blog at Columbia University. She covered space exploration for several years as an editor at *Popular Science.* Her articles have also appeared in the *New York Times, Scientific American, National Geographic,* and many other publications.

BORN 10 FEBRUARY 1942 BRONX NEW YORK
ATTENDED THE NEW YORK PUBLIC SCHOOL SYSTEM.
THE LATE FIFTIES AND EARLY SIXTIES WERE SPENT TRAVELING
THROUGHOUT NORTH AMERICA (USA · MEXICO AND CANADA)

THE FIRST PRESENTATION OF THE WORK WAS IN MILL VALLEY
CALIFORNIA IN 1960. LAWRENCE WEINER DIVIDES HIS TIME
BETWEEN HIS STUDIO IN NEW YORK CITY AND HIS BOAT
IN AMSTERDAM

HE PARTICIPATES IN PUBLIC AND PRIVATE PROJECTS AND
EXHIBITIONS IN BOTH THE NEW AND OLD WORLD
MAINTAINING THAT:

ART IS THE EMPIRICAL FACT OF THE
RELATIONSHIPS OF OBJECTS TO OBJECTS
IN RELATION TO HUMAN BEINGS & NOT DEPENDENT UPON
HISTORICAL PRECEDENT FOR EITHER USE OR LEGITIMACY

LAWRENCE WEINER

Acknowledgments

We would like to thank the following for their support in the creation and completion of this volume of *SOM Thinkers, The Future of Public Space:*
Kelly Chan, Alejandro de Castro Mazarro, Nicholas Adams, Jeff Byles, Frances Anderton, Sharon Helgason Gallagher, Terry Tempest Williams, Jason Anderson, Jacqueline Khiu, Eugenia Bell, Diana Murphy, Philip Nobel, Jud Ehrbar, Claire Nau, Will Self, Emmy Catedral, Neil Donnelly.

The articles in *SOM Thinkers, The Future of Public Space* are prepared by individual authors in their capacity. The opinions expressed are the authors' own and do not necessarily reflect the view of Skidmore, Owings & Merrill.

Editor: Amy Gill
Editorial assistants: Kelly Chan, Joshua McWhirter
Copyediting: Eugenia Bell
Series design: Neil Donnelly and Sean Yendrys
Volume design: Neil Donnelly
Printing: Shapco Printing, Minneapolis, Minnesota, USA

This book is set in Concorde and Plain and printed on 80#
Rolland Enviro 100 Smooth Text, Cover stock: 100# Rolland
Enviro 100 Smooth

ISBN 978-1-942884-16-3

Metropolis Books
ARTBOOK | D.A.P.
75 Broad Street
New York, NY 10004
T: 212 627 1999
F: 212 627 9484
www.artbook.com

MIX
Paper from
responsible sources
FSC® C005259